In Her Place

inner views and outer spaces

photographs by **Peggy Fleming**

Peggy Fleming
2001

WITHDRAWN

IN HER PLACE
inner views and outer spaces

First Edition

Copyright © 2000 by Peggy Fleming

ISBN 0-9676322-0-X

Library of Congress Catalog Card Number: 00-090283

Fleming, Peggy In Her Place: inner views and outer spaces.
Photographs by Peggy Fleming
 Includes index.
 1. PHOTOGRAPHY/Portraits/Environment/Photo Essays.
 2. SOCIAL SCIENCES/Women's Studies/Anthropology Cultural.
 3. HEALTH AND FITNESS/ Healthy Living.
 I. Title.

Book design, cover design and logo by Alice Quatrochi, Alice Quatrochi Designs
e - mail: aliceq@gateway.net

Pea Shelling © Neva E. Marks

Reflections on In Her Place © 1999 Ruby Takushi

Photographs © Peggy Fleming

Printing: Virginia Lithograph, Arlington, Virginia

Publisher: **three sisters press**, P.O. Box 42149, Washington, D.C. 20015
In Her Place can be ordered from the publisher or by e - mail.
e - mail: peggyf@aod.cx

Reflections on
In Her Place

by Ruby Takushi

Seattle, Washington
1999

Each of us has a place, real or imagined, where we go to rest, gather our strength, and remember who we are. Peggy's photographs show women of all ages, each in her place — in a garden, on a motorcycle, at a table in a mall. When we first met I was anywhere but in such a place. I'd just left my position as a teacher, sold my beloved house, moved across the country, started a new job, and birthed a daughter. Slowly, I sorted through the various pieces of my life and discovered they would not fit comfortably together until I'd first found a place to center and restore myself. At other times, in other cities, I've had such places. In college I'd sit at the ocean, feet touching the water so that all the hardness in my heart would wash into the sea, and I'd feel reassured that all was well. Another favorite was the 5:30 a.m. drive to the early shift at the hospital. I would sing songs without worrying anyone would see or hear. And I've always liked the library because I can be or not be industrious, and no one can tell.

Sometimes we forget our past. My mother taught me the importance of creating a place for oneself. The only time that was hers was in the early morning as she prepared the offering for the family altar. I would hear her in the kitchen while it was still dark outside: the sound of her footsteps, the rattle of crockery, then the strike of the match as she lit the incense. She repeated this in the late afternoon, and sometimes I'd watch and share that moment with her. There was an easy rhythm to those times that soothed the usual household chaos. I imagine this was her only quiet space. It was her place, because in those moments she was centered, or at least trying to be — aside from her telling me that she liked to pray everyday, we never talked much about why she valued this space. But this memory is one of her gifts to me. She taught me that quiet attention to the sacred is one way of finding one's place in this world.

After three years in a new city, I'm still not completely sure which pieces of my life will stay, and which will go. But I'm closer to knowing what to do because I've found a place where I can sit still. I sit in our sunniest room. Usually in the morning, on our too-soft, but familiar sofa that came across the country with us. I sit within earshot of my sleeping girl. Sometimes I remember the people and places that give me strength and help me to hear what is calling me into the coming day. I have a cup of coffee. I watch the pear trees out back. I scribble in my journal, write letters, look at photographs, plan my summer garden. Sometimes I cry. Sometimes I pray. I remember where I come from and who I am. And then it's time to go.

Pea Shelling

by Neva E. Marks

Nashville, Tennesse
1978

My grandmother

would sit on the porch

on early summer mornings

an empty pan perched on her lap

and she'd hum a favorite hymn

as peas released from hulls

pelted the metal vessel.

I, a child of eight, watched

baffled by her patience and enjoyment

of such an ordinary task.

Now, in my fortieth year,

as days speed by

encouraging haste and stress

I feel a longing for peas

layering the bottom of Mama's basin,

humming.

Adama Sall

Writing is peace of mind;

a fresh piece of paper and

a great pen that will

just flow across the page.

My ideas, fears and hopes

are all down on paper.

They wait,

for whenever I'm ready

to deal with them.

1996

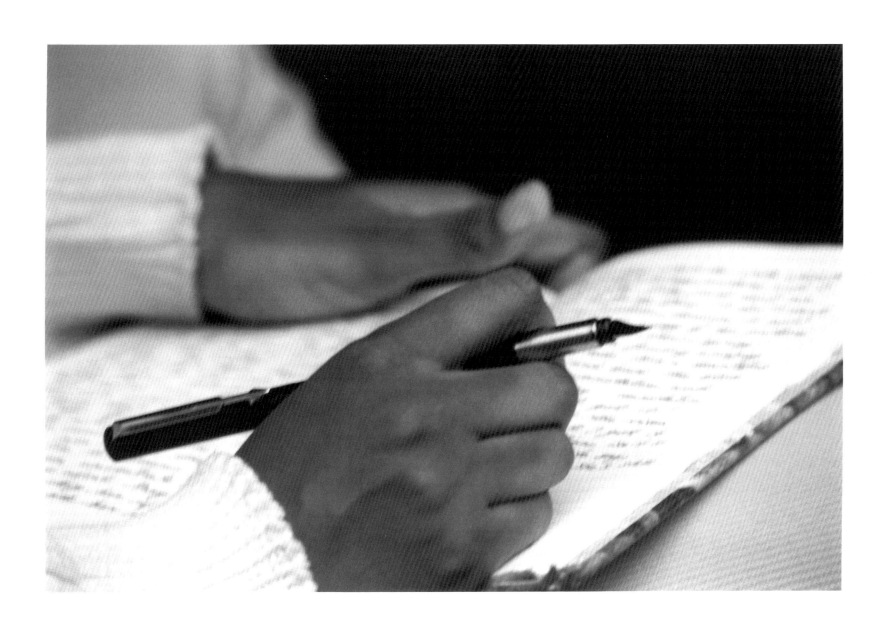

Trudy Chandler

Doing puzzles is
the only time I have solitude.
R & B, Natalie Cole and
Ronnie Jordan music is on.
I light a candle
underneath a potpourri gel
of White Gardenia.
I'm relaxed.

As a kid I would take my toys apart because
I wanted to see how they worked.
Now I like to put puzzle pieces together,
to see how they relate to one another,
to see the whole —
and in so doing I also see the details.

By observing people's body language,
hearing their stories,
sharing day to day experiences,
I piece together the pieces of the puzzle
that is each person.

1999

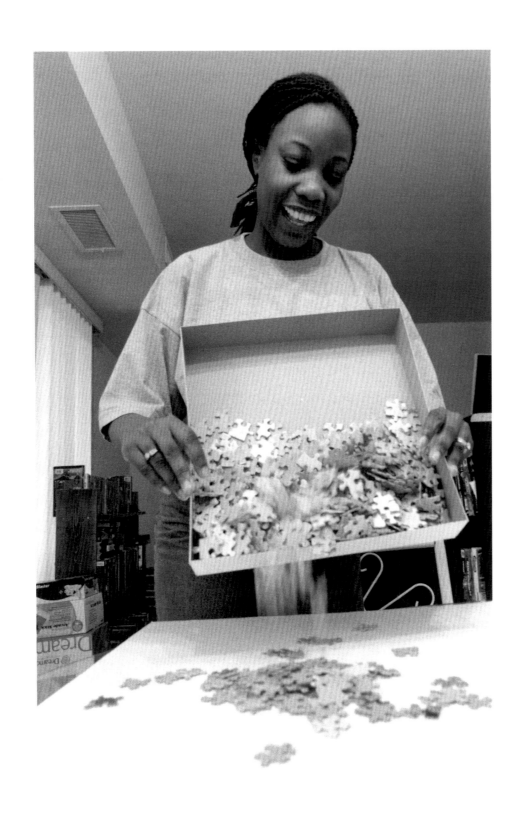

Candida Fraze

Play feeds my work

and it might be anything:

kicking leaves,

making wreaths from vines

in the park,

canoeing at Swains Lock,

scouring thrift shops,

having a wicked lunch somewhere,

discovering a new art gallery or

simply lying under a tree.

I play alone and

I play with friends.

My work is play when it works.

1999

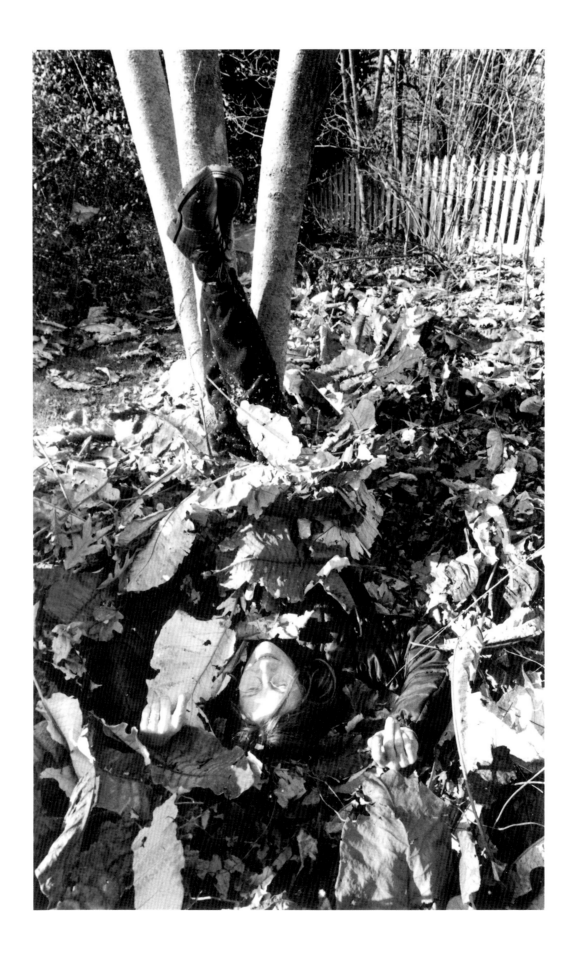

I feel happy sharing with

my brother and sisters

in singing to God

and praising Him.

Berthilda Davila Solis Rocha

Yo Le alabo con el corazon

Yo Le alabo con mi voz

Y si me falta mi voz

Yo Le alabo con mis manos

Y si me faltan mis manos

Yo Le alabo con mis pies

Y si me faltan los pies

Es que me he ido con El.

1996

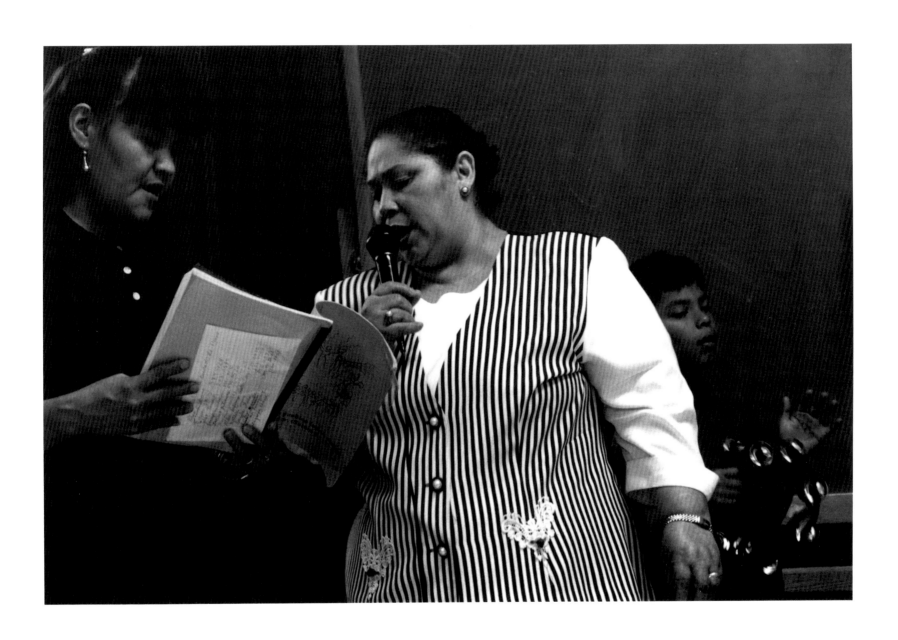

In water, I fly

 In water, I swim

 In water, I am free

 In water, I am water.

My lines feel more defined in water.

 My mind and body and energy

 run clean, and clear

 like the water.

A pool is my piece of happiness,

 my watering hole,

 my peace.

1995

Elizabeth Vaughan Carroll

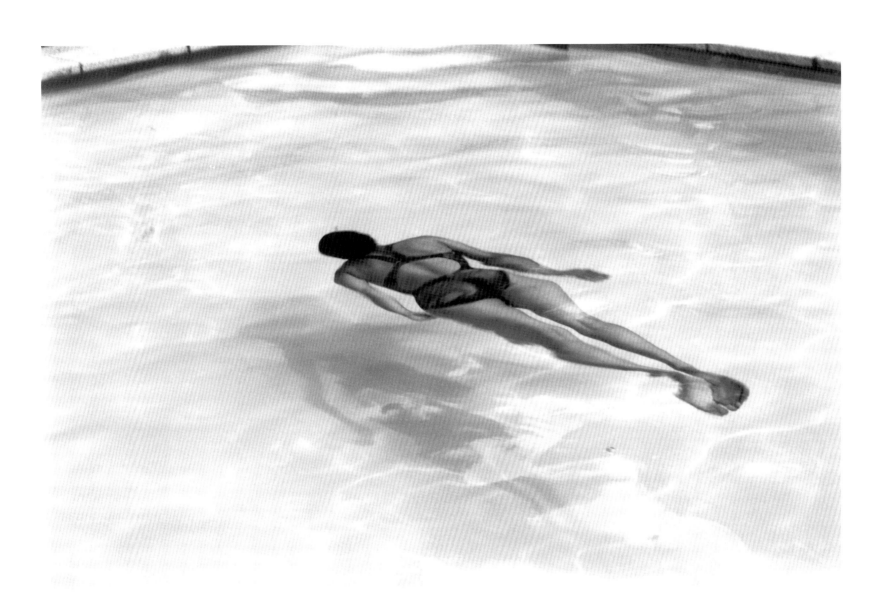

Charlotte Skene Palmer

Music makes me happy.

For thirty years I did not have

time to play the piano.

Now I play every day

all by myself, for myself.

My jobs are finished;

my commitments are volunteer.

I totally and completely enjoy

the feeling of a great time

and peace when I play.

Besides, the playing

rejuvenates my fingers.

1996

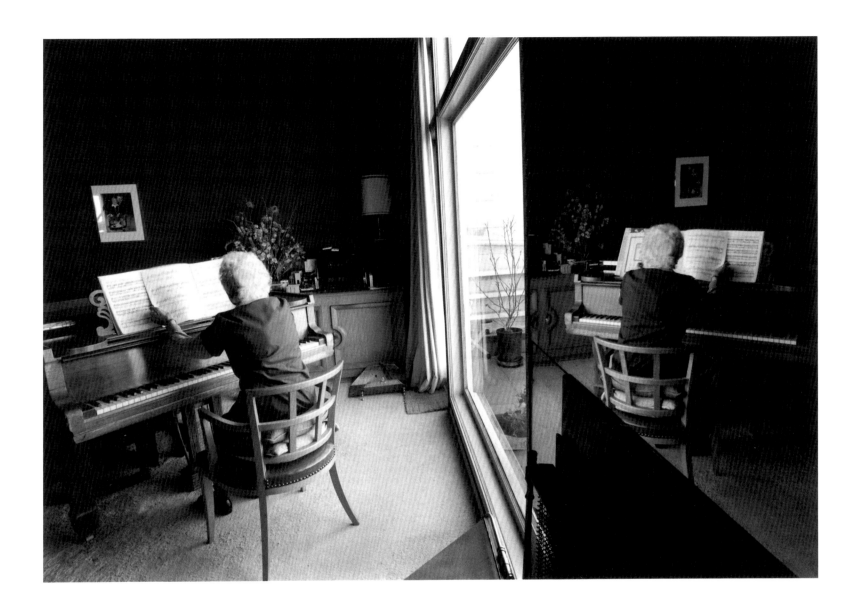

Helene Tiranova Chakos

Cooking is creative.

I use herbs

from my garden.

The food tastes good and

makes me and others happy.

Of course, praise

is always welcome.

1997

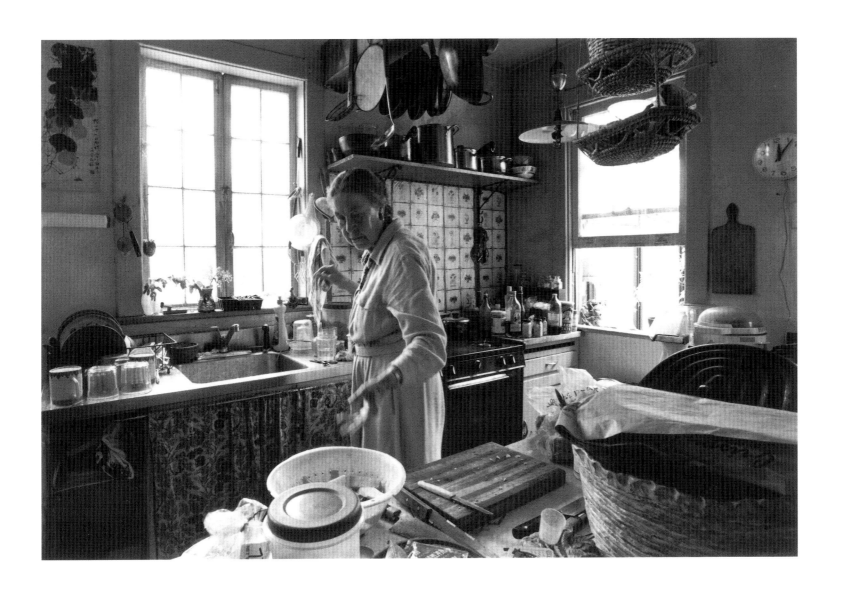

Cici Mukhtar

Not work, but at work,

at Polly's.

I make an atmosphere

that is playful and fun.

Laughing loudly,

thrilled to be "in the moment".

My friends tell me

they know where I am

from a block away

if I'm laughing.

I am not a quiet person;

I do not enjoy solitude.

In my place, defenses are down,

confidence is high,

friends are close and

laughter is everywhere.

1999

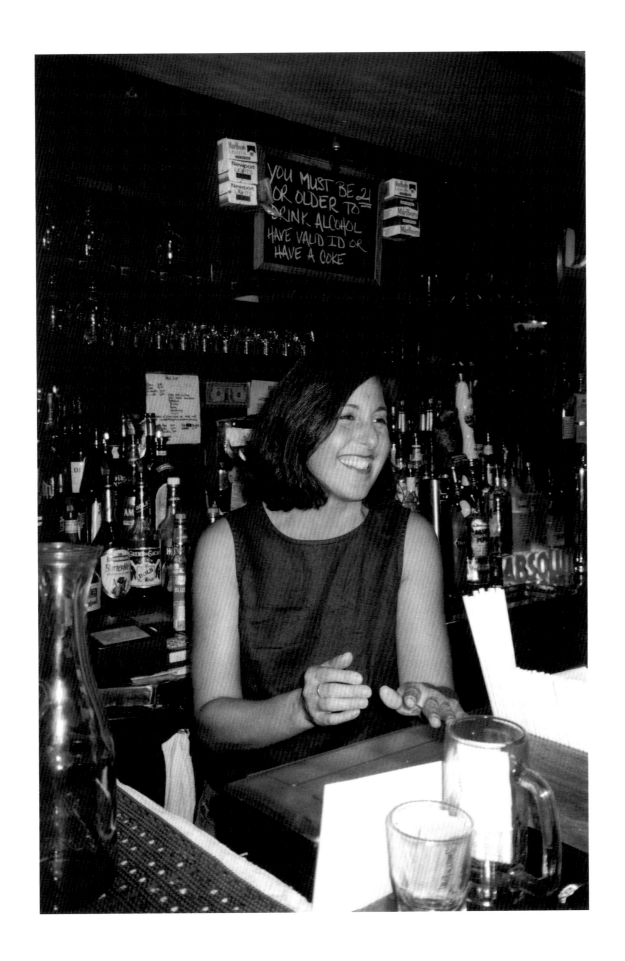

Kate Krizan

I love to drive

alone. I control my

entire environment in the car:

hotter

c o o l e r

LOUDER

quieter.

Long drives are the best.

My mind travels

thousands of times faster

than my car and

while driving I

have nothing better

to do than go where

my mind takes me.

1997

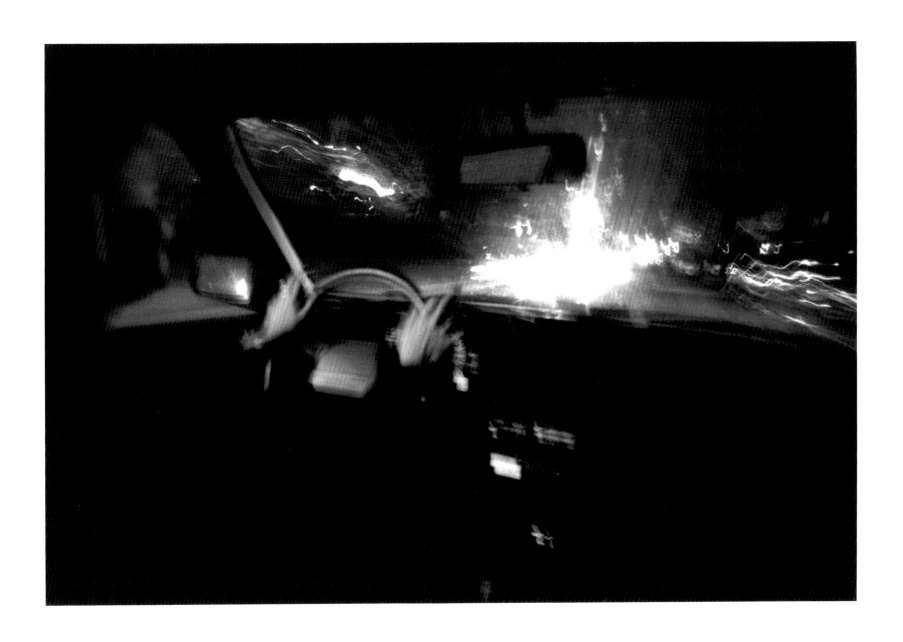

Melissa Berkoff

My place is on the racetrack

because the thrill, excitement,

danger and challenge of racing

make me feel alive

like nothing else I've found.

The racers, teams and crews

treat each other with respect,

and unless you're a complete asshole

and violate the courtesy code,

you're accepted.

The friends and spectators

who show up

make you feel accomplished,

even special.

1999

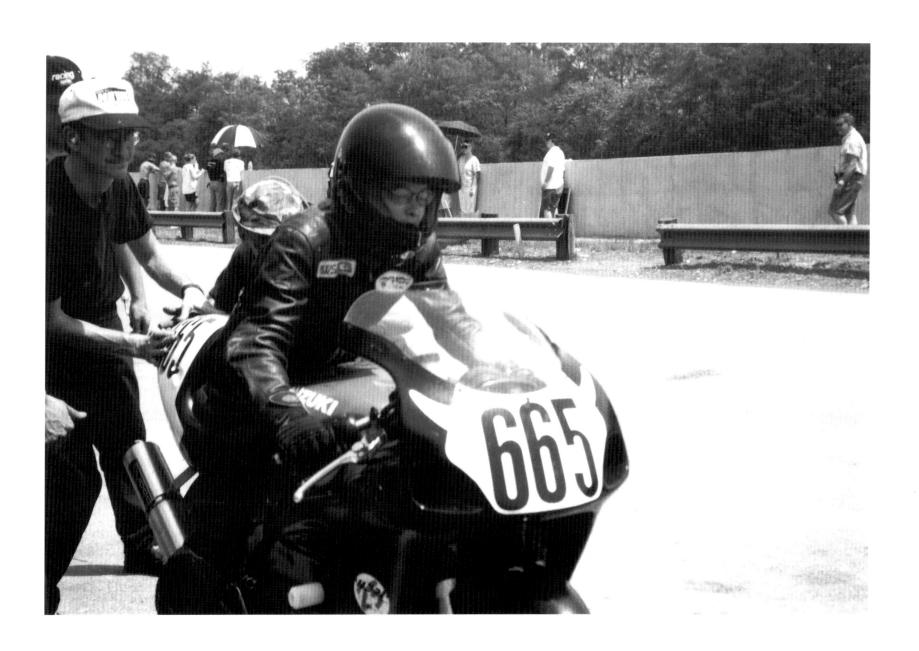

Kazumi Yoshida

With my head on my husband's stomach,

I am calm and free.

His stomach is a little bit fat,

so it's soft.

I am blank in my mind.

Nothing thinking.

Nothing worried.

1998

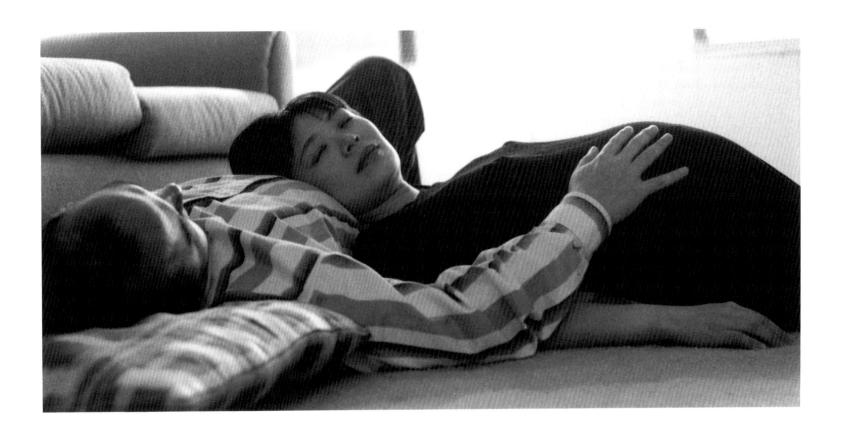

Le Thanh Lai

Growing orchids is a challenge.

As I water and take care of them,

I look for buds.

When they bloom, I am successful:

I know I did something right

and I am happy.

When my parents opened

Huong Que Restaurant,

the landlord gave us an orchid

as a present.

It was the first time I saw such an elegant flower.

I learn about orchids from books,

customers, and my "uncle".

Arranging orchid bouquets

for the restaurant

I do also.

I dream to open a flower shop.

1999

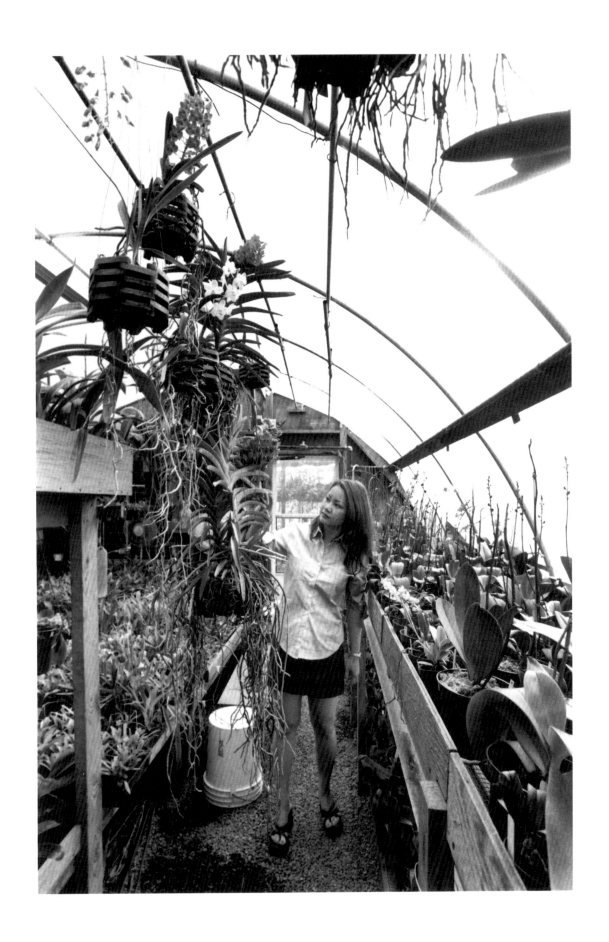

Lydia Mendoza

When I feel down,

have mood swings

or am overwhelmed,

I get on my bike.

Fresh air, space, exercise.

All that clears my mind.

It is a time to think,

to put things into perspective.

Time alone.

By myself.

I do this for me.

1996

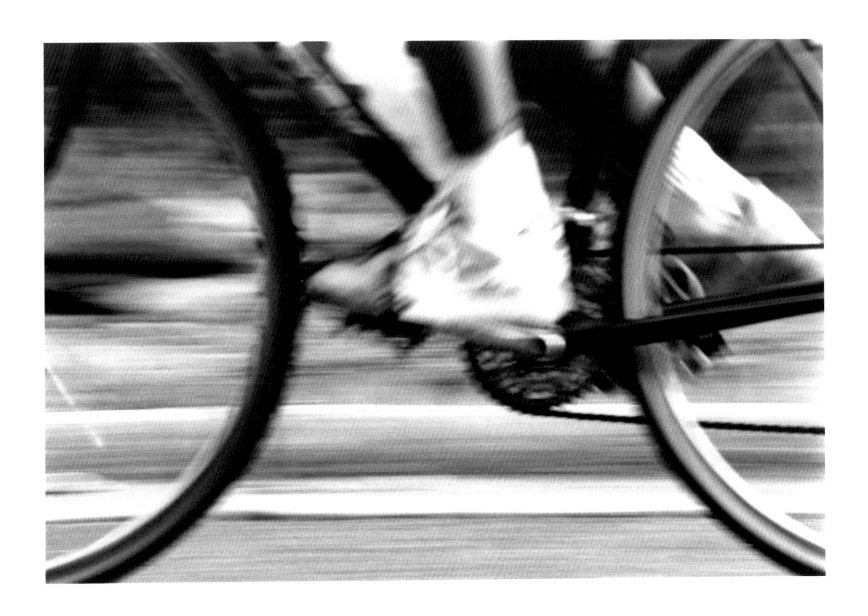

Zahra Dianat

I have a busy mind, busy schedule.

Meditation quiets everything in me

d o w n.

Next to my bed, on the floor,

meditating and reading

are my daily activities.

I grew up without parents

so the books helped me grow up

and know myself.

All the things I did not have in real life

I have in meditation.

Now — I rely on people

for life learning

as well as books.

1999

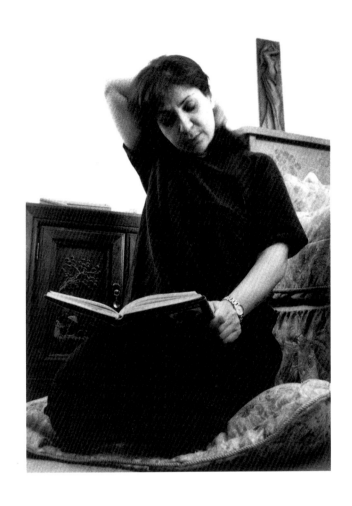

Liesbet Koromzay

On a summer morning:

to step out into the garden,

to salute the sun,

to stretch my body,

to feel utterly peaceful,

That is heaven.

1997

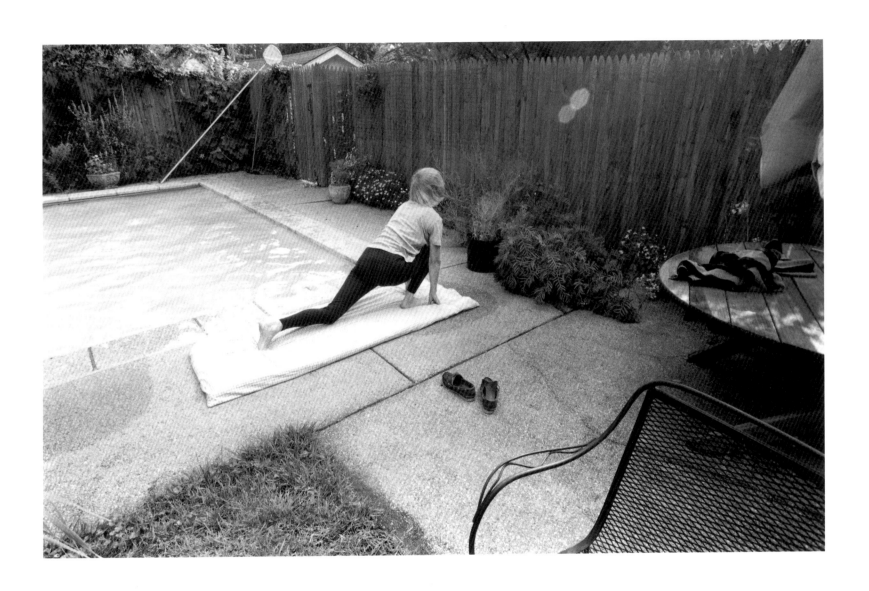

Elaine Muoio

What I like about taking a shower

is the ritual and sensuality.

The pattern of the ritual is:

place the clean clothes on a chair;

turn on the hot water;

take off the worn clothes and

toss into the clothes basket;

enter the hot, steamy shower.

The water runs all over,

from head to toe,

touching my body

pleasurably. I sigh and turn.

Soaping and scrubbing.

The rinsing is a slow turning.

Then dry and oil my body,

to complete the ritual,

to feel an inner cleansing.

1997

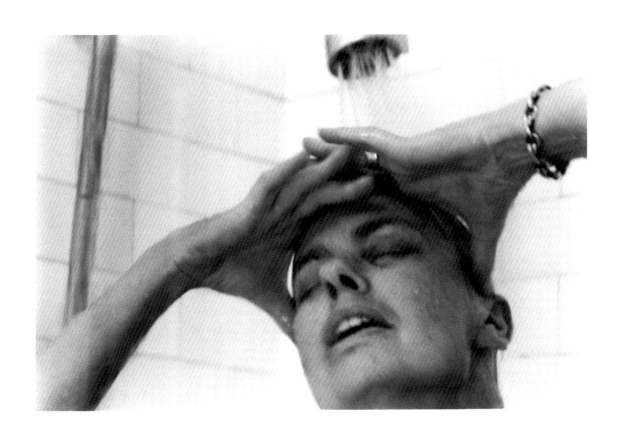

Sarah Kwon

I have a large requirement for sleep

in the middle of the day:

in bed with pillows

and covers

and my dog.

Uninhibited

by restraints of clothing.

With dreams and private thoughts.

Afternoon sun

streaking through my window.

I am a night owl.

1999

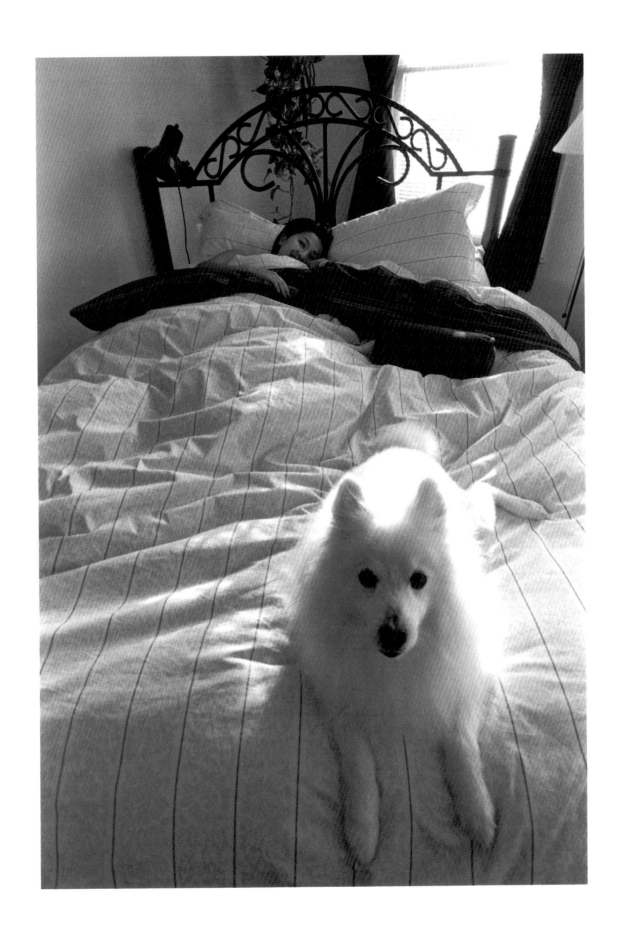

Ruth Addie Everette

Home is my favorite spot;

I am a homebody.

After getting home from work,

I eat a bite,

spend time with my daughter Rachael

and my mother.

From eleven to midnight, I sit

in my comfortable dining room chair and

gather my thoughts, my lists, my calendar.

Then I relax.

I read scripture and

talk with the good Lord.

My "hallowed time" is

in the morning.

I make a cup of tea, feed the cat,

make lunch for Rachael.

1999

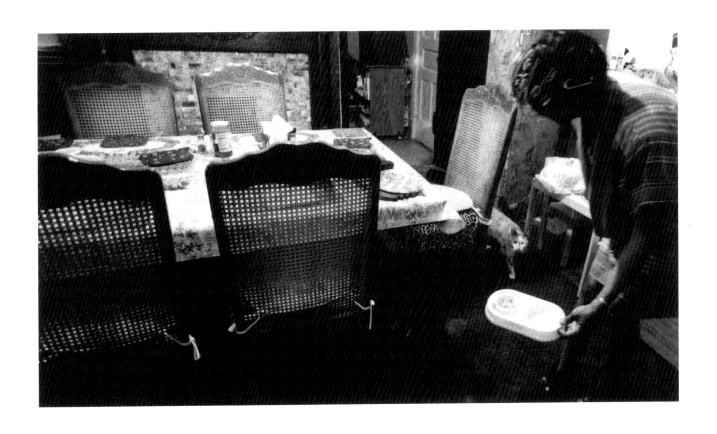

Kyung Choi

Every night

I call my Mom long distance.

I don't talk much.

I listen to my Mom talk

about what she is eating,

about her friends,

about my sisters and brothers.

I am very busy now

with no time except for

my family and work.

I feel good hearing her voice.

1997

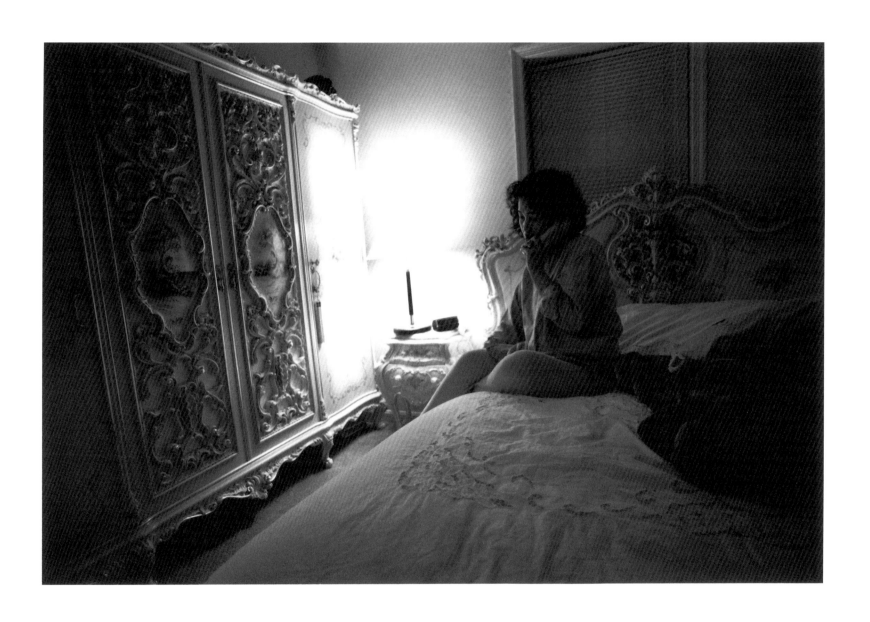

Anna Shakeeva

Like dreams,

once I start working

I forget about the original idea

and I work.

So many brush strokes takes time.

I don't make the work;

the work makes me.

1997

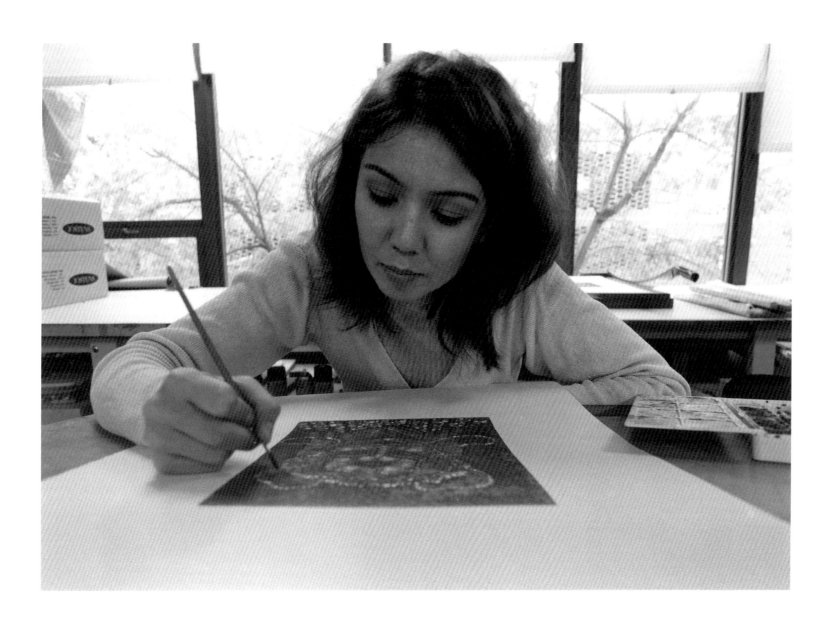

Michiko Mitsuyasu

To my surprise,

gardening has become

my place of relaxation.

Why?

Maybe because

I can see life in watching

the plants growing.

1997

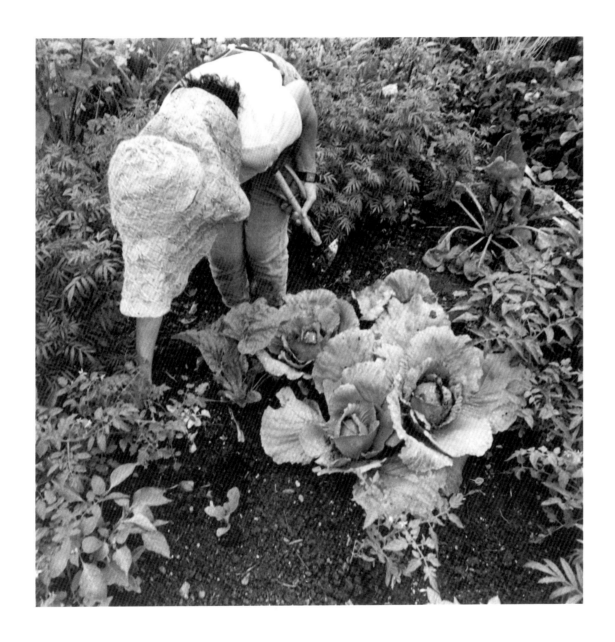

I'm always looking.

I'm fascinated with how things change

with light.

I'm always looking for surprises.

I enjoy my friends but

I'm happy to be alone.

Ruth Bernhard

It is characteristic of me —

what I collect.

I like beauty,

the small life,

the helter skelter.

A pine cone is ... a forest.

1996

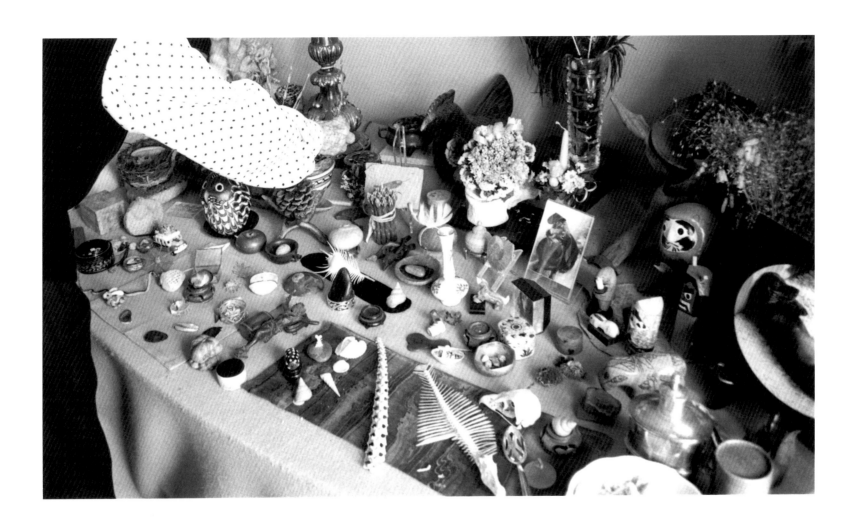

Megan Patricia Whilden

An octopus is a good metaphor for me:

eight tentacles,

each poking around into different tasks,

ideas, trains of thought and questions.

This can confuse others, and myself.

Sitting on my bed,

with the mail, magazines, bills, letters

and things to do spread around me,

I begin to focus and relax.

I absorb one item at a time.

I feel at peace for a little while.

1995

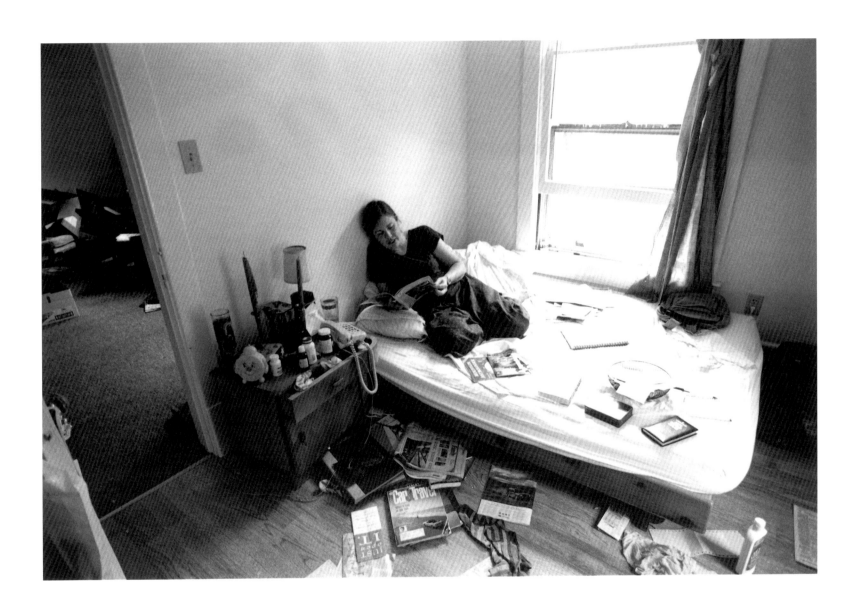

Dorothy Ray Healey

My program

on Pacifica Radio, since 1959,

"Dialogue" or "on my soap box"

allows me to vent

my indignation over

oppression and exploitation.

As a result

I don't get ulcers, I give them.

I am a life long believer in

a socialist alternative to

a capitalist economy and

commercially driven society.

1995

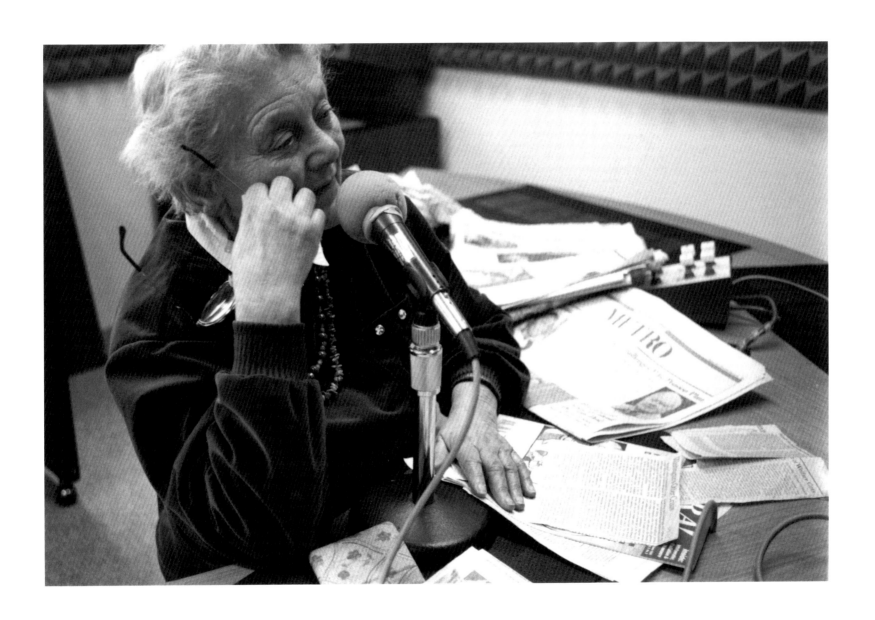

Carla Cohen

Politics & Prose Bookstore

energizes me and fulfills all my needs.

I'm the big boss and I love it.

I thrive on the daily interacting with

the staff and customers,

the hustle and bustle.

My creative juices are going.

I have a lot of ideas;

I can put them into action

immediately.

1998

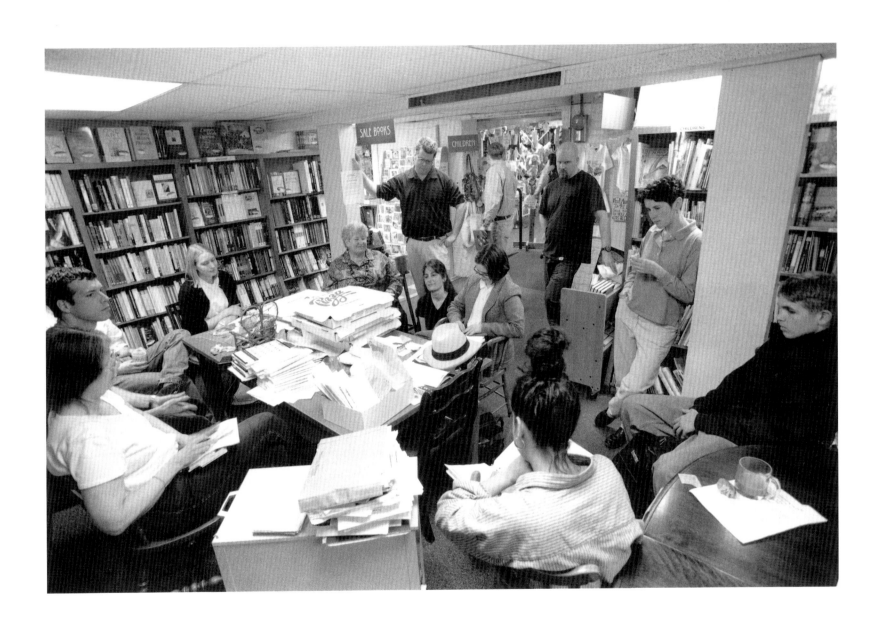

Alice Quatrochi

I work from home

so I can be close to my children.

Some think staying at home

will stunt your personal growth.

But being with my children,

day by day,

transforms me.

My innermost voice surfaces

and challenges me

not just to

live my dreams

but to share them.

1996

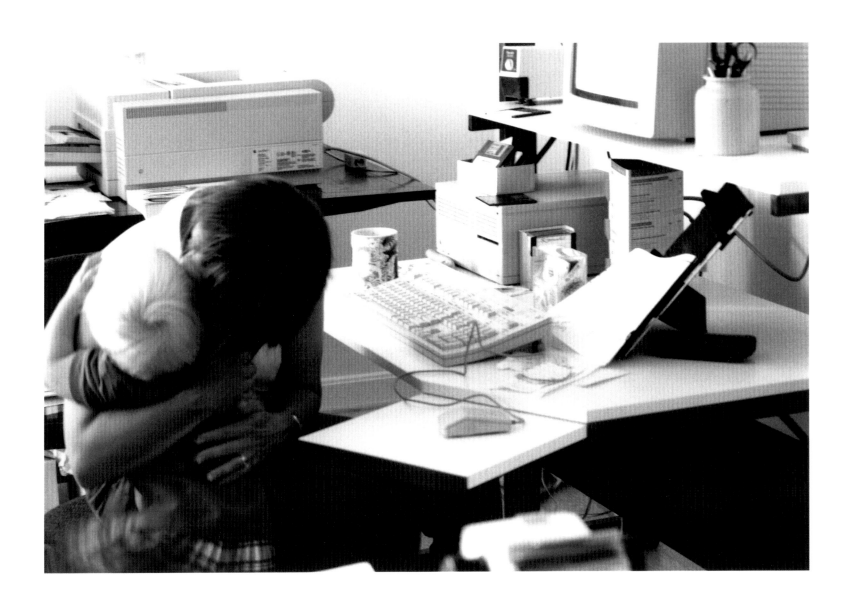

Eileen Owens

Being a single Mom and

having a full time and a part time job,

it is hard to have time to sit down.

At least one time a week

I enjoy sitting down with the children

and eating supper.

No matter what my week was like,

being with them

always makes me feel

like everything is going to be all right.

During these times

I see my strengths and their strengths:

confidence, seeing the good in situations,

patience, no nonsense,

friendliness, dependability.

1999

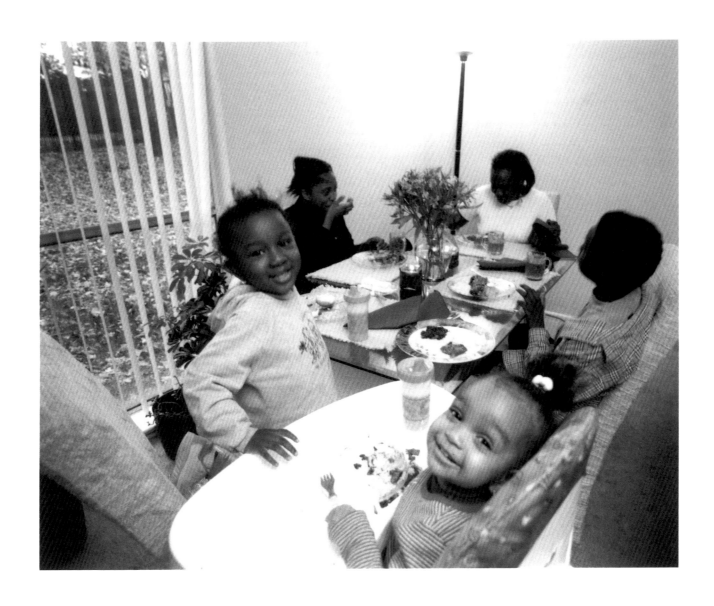

Barbara Meade

The last 15 years
have been work focused;
now I would like to be
more family focused.
Now that I'm GROWN-UP,
I am more capable of having
good relationships with my kids.

Given the nature of my work,
I spread myself too thin
between staff, sales reps and customers.
I skim the surface of relationships
with so many people.
So to have one on one
is nice.

Reading with Sophie is
a cyclical repetition of generations.
I read with her what I was read to as a child
and what I read to my children.
While reading, so many things come up
that we can talk about.
An easy sharing,
especially given the gap between our ages.
When she spends the night with me
she comes with 3 suitcases full
of dollies, stuffies and Barbies.
We read before going to sleep.

1999

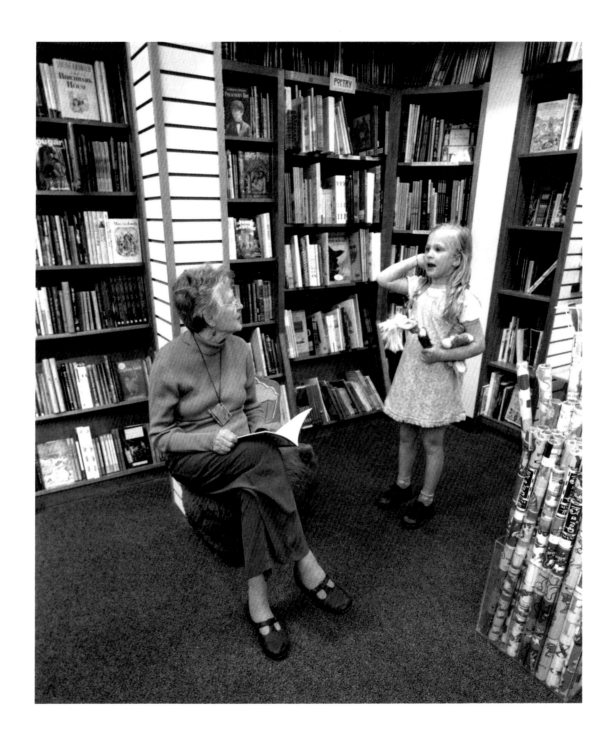

Frances Whitlow Fleming

Since Joe died,

the early morning hours

have become a time

of peace and contentment.

Some of this comforting time

I spend reading

two or three chapters of the Bible,

It sets the tempo of my day.

I have read the Bible,

Genesis to Revelations,

several times, adding to my appreciation of it

as literature and hopefully

increasing my understanding

of its message.

On this date

I am beginning

my seventh reading

of the Good Book.

1997

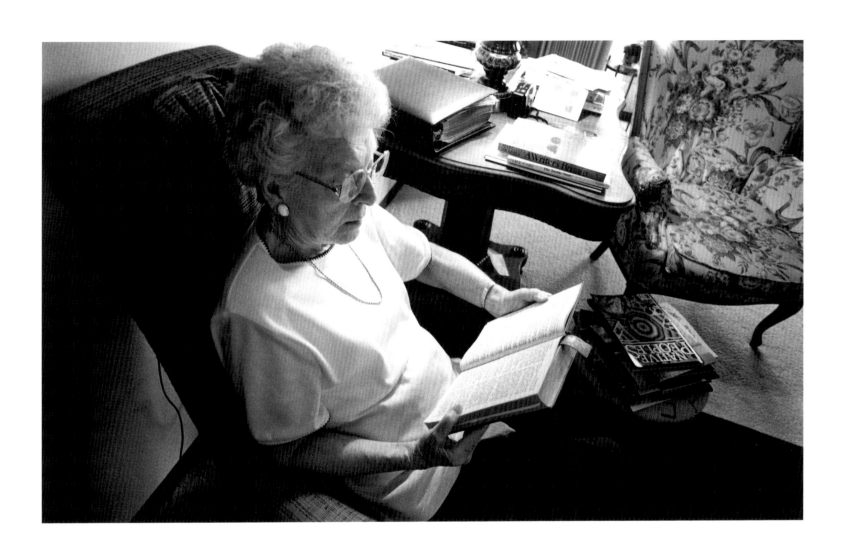

Lori Wallace

Painting and drawing the visuals

that come into my consciousness

allow expressions of my soul.

Having a blank canvas or

piece of paper before me

is like being a child in a candy store.

Questions arise and answers come

from being satisfied by

what I view of the creation.

We are all blessed

in many different ways.

This is my blessing.

1998

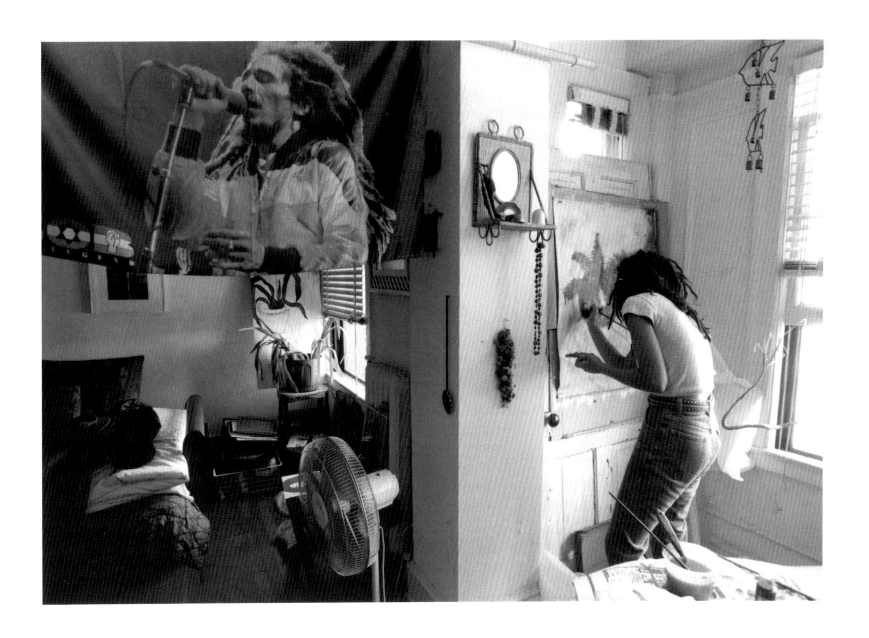

Amy Pickering

My office is a room in my friend's house.

I've spent from my late teens

into my 30's here.

Photographs, letters, and

an amassing of years of small evidences

from the fans who write to

Dischord Records

clutter almost every wall.

From this haven

I've written to thousands of kids

who are looking

for just the stability

that I have in this place.

I try to pass on

the warmth that surrounds me,

and in turn,

it is returned to me

over and over again.

1995

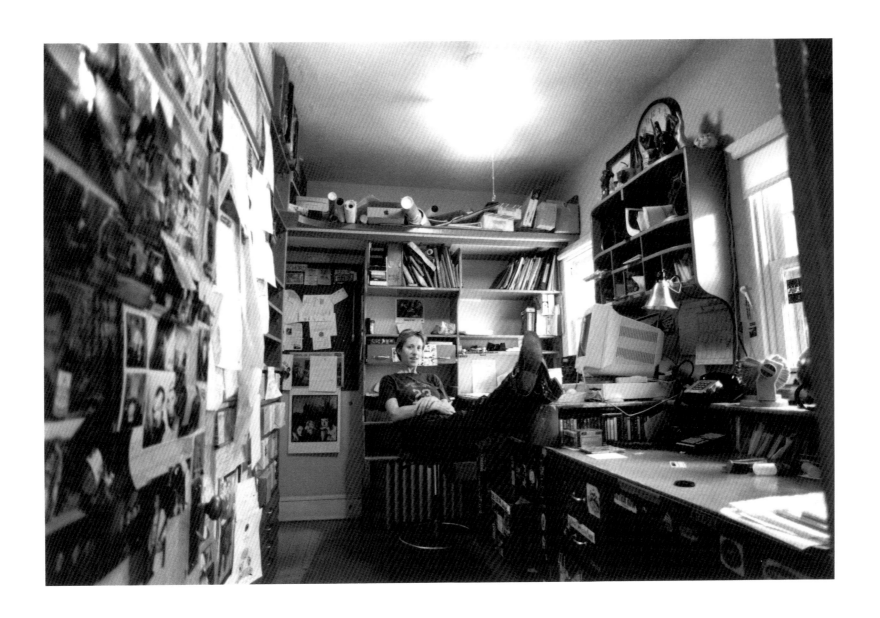

Karen Claudia McManus

Roman Catholic by training,

Pagan by preference,

I still nurture myself by prayer.

I have moved out of the church

of stone and stained glass,

outside into the fresh air

under the heavenly sky.

I worship not

under the crown of thorns, but

beside a breathing "flock"

of bushes, herbs, flowers and trees.

"Hail Mary,

mother of Nature,

blessed be thy raspberries ..."

1999

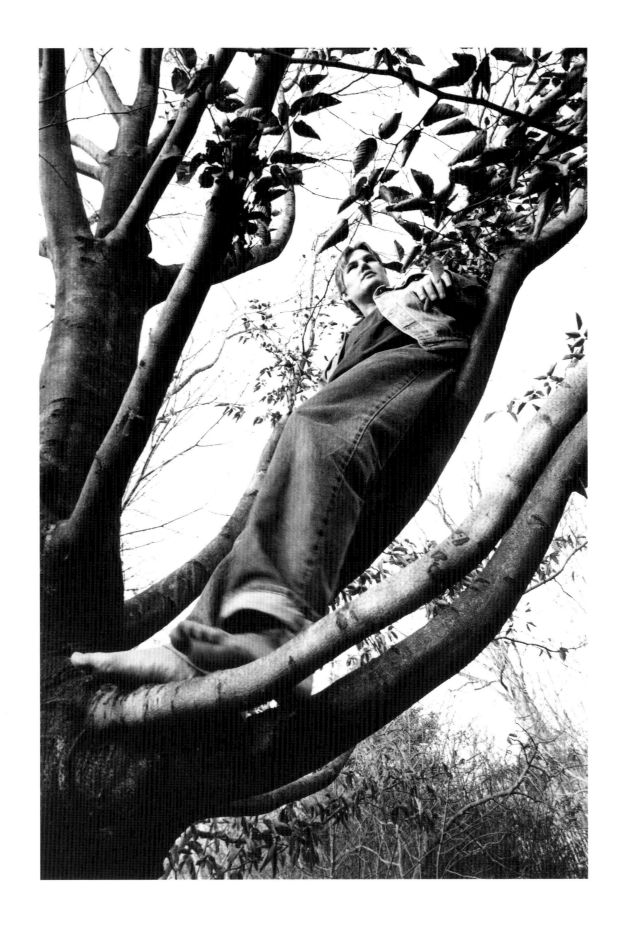

In the car, I feel powerful

and in control.

I decide where I'm going.

In the car I have my music,

Mary Chapin Carpenter or *Nancy Griffith,*

the wind in my hair.

carefree stuff, especially

when the kids aren't in the car.

Sally Ellis

Taking Lucy with me

is a way to get her out of the house,

to stop her barking and

I do some errands.

Lucy brings interactions.

People smile at her and some come over —

and then I have to end the magic

by saying "she bites".

But if they don't come over

and just smile,

we all smile.

1999

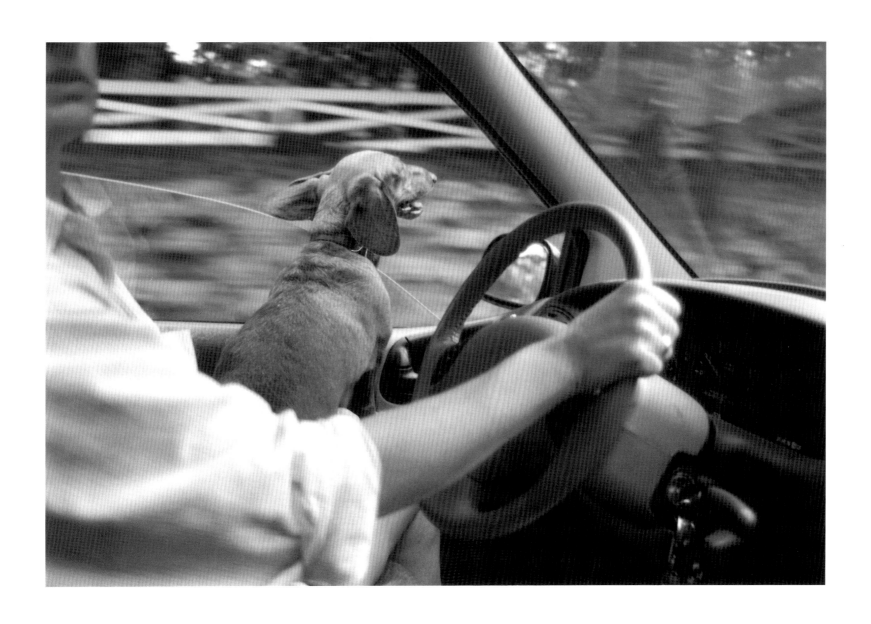

Sandra Rottmann

I am a Peruvian-born American
of Romanian Jewish parents.
I was raised in Lima, and
live in Washington.
I speak Spanish, French, English,
and some Yiddish.
I don't feel that I belong
anywhere, especially
according to culture or language.
I am more of a permanent exile,
or outsider.

My place is the kind of space
where the internal world
and the external world coincide.
It is no place in particular.
It is a state of mind:
a moment of connection ...
with a person,
an animal, a landscape.
It could be
any where, any place,
any time.

1999

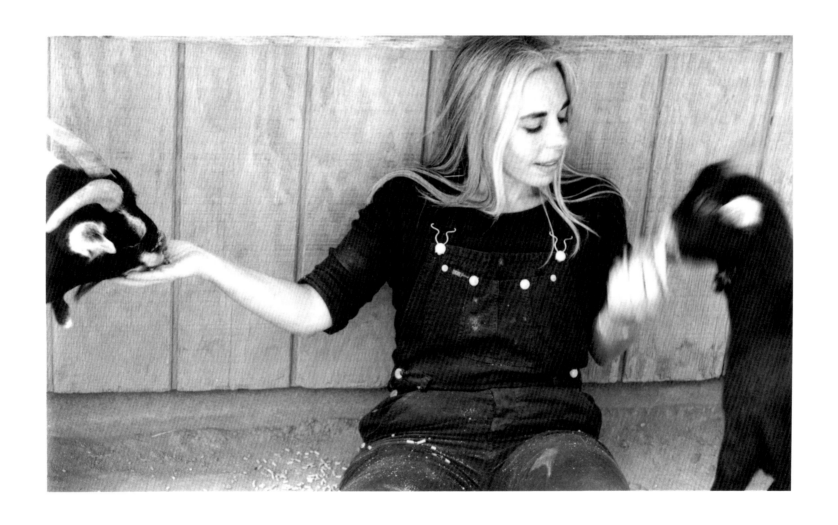

Donna J. Turner

My relationship

with horses is a small Eden,

shared first with Coquette,

then with Jody,

and now with Pip.

Each of the three animals grew

endearingly familiar yet

was always full of surprises.

Going out adventuring,

I'm 10 again.

My horse's home is also

a home for my heart.

1995

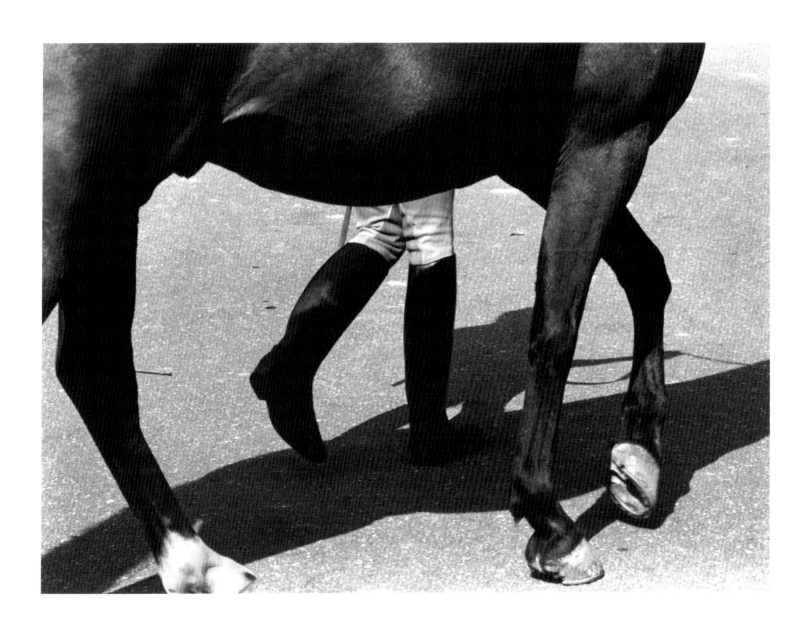

Diana Holmes

My meditation practice

is vital to me.

At home

I have all the earnest paraphernalia,

the cushions, my prayer beads,

a simple shrine, a quiet corner.

But my most effective practice is

on the Metro

between home and work,

work and home.

For this hour a day

I am out of the whirl,

not mother, wife, worker, or friend.

My monkey mind settles

more easily here,

surrounded by

the lovely faces of strangers.

I am glad to be coming,

glad to be going,

glad to be traveling alone.

1998

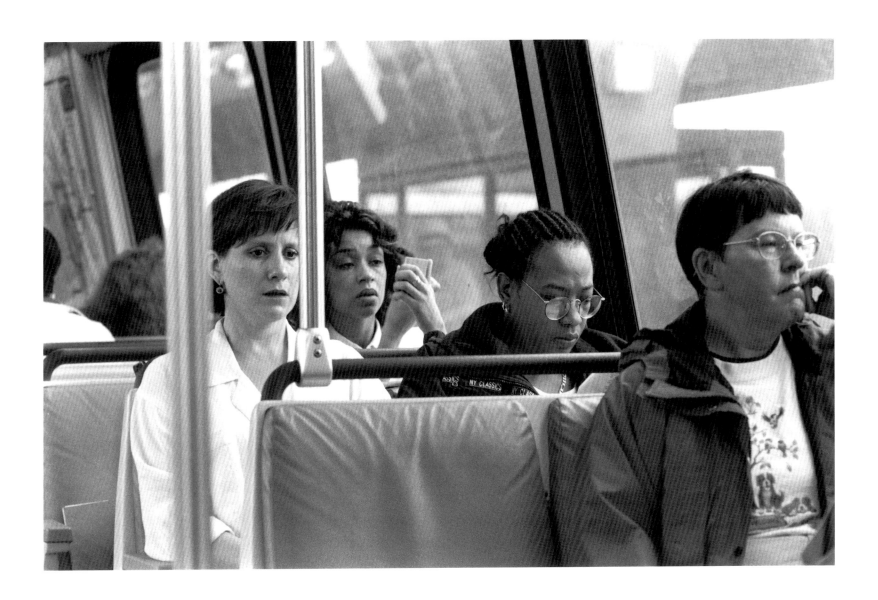

Timmy Napolitano

People replenish me.
Establishing relationships
through talking and listening
is part of my being.
My relationships include
my husband of 37 years,
our children,
my sister and brother,
the Unitarian community, and
the young staff members
at Common Cause where I volunteer.
We share our hopes for a better world
with more social justice,
more equity and more tolerance
of other people's views.
Watching them and
interacting with them
inspires me.
We are optimistic that
our actions as individuals
can make a difference.

1999

Doris Poliakoff Feinsilber

Walking in my neighborhood

is a time of pleasure

in the out - of - doors, in all seasons.

My routes are familiar.

I watch lingering icy patches,

catch the first blossoms of spring,

enjoy the rich colors of autumn leaves,

the changing colors of the sky,

the smell of evergreens.

It's freedom

and it's good for me.

1998

Toija Riggins

Modern dance,

being in the studio, in rehearsal,

and on the stage;

these are my passions.

Dance requires focus and concentration:

how to do the movements correctly

and when to do them;

where you are in space;

where the other dancers are;

m u s i c a l i t y;

 r h y t h m.

Being able to control my body and

express myself through movement are

major self-esteem boosters.

Creating beauty and art

in tandem with other dancers;

we spend so much time together,

we become like a family.

1999

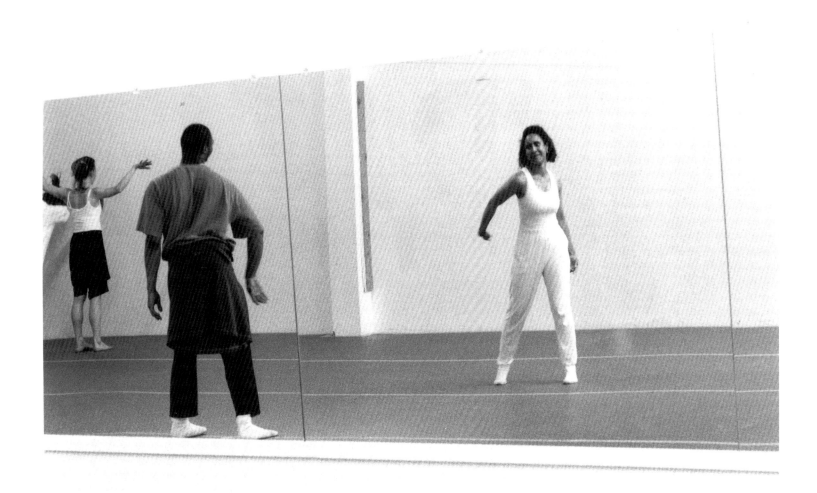

Rives Carroll

When I finally lie down to read,

I feel as though I'm on vacation.

I give myself permission

to just "be".

I let go of the responsibilities

and duties.

I'm making a choice

to do something for myself,

rather than responding

dutifully to an obligation

or a relationship.

I slow down,

I stop.

With my feet up,

I can't go anywhere.

My body is still

while my mind does the traveling.

I think.

I'm in the present.

I'm peaceful.

1996

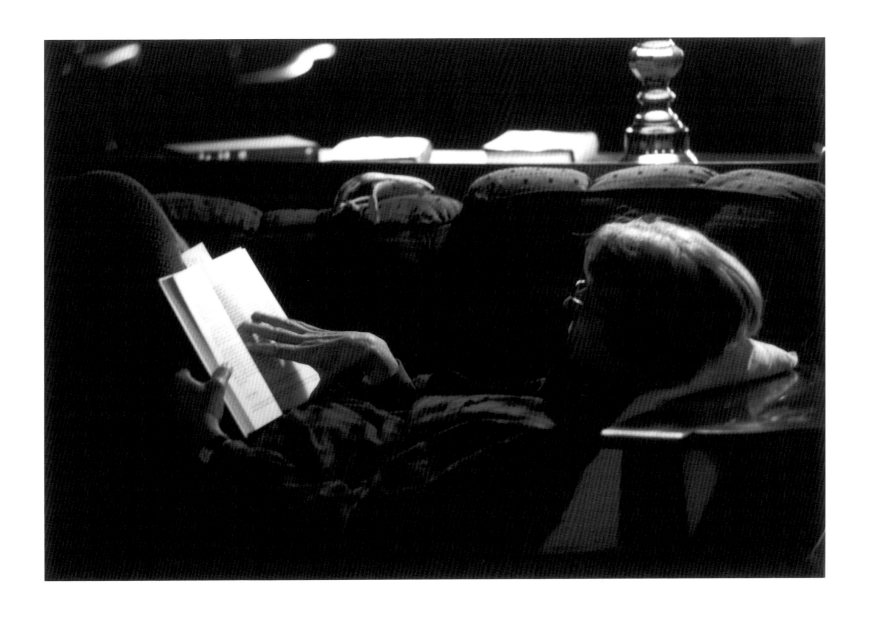

Patty Dougherty

Morning ritual: mug of coffee,
New York Times.
Often before sunrise.

I always use a pen,
no erasing.
I can't stand pencils.

The NYT puzzle is well constructed and
gets more difficult throughout the week.
Monday is easy. Saturday is a real stumper.
To finish a hard one is satisfying.

I like the boxes and the patterns,
the word plays - some times straightforward,
some times with twists, all the time fun.
My least favorite are quotations.

The challange is to see if my mind
can go further than what is just right there —
to find the key and how the answers
are related to each other.

1999

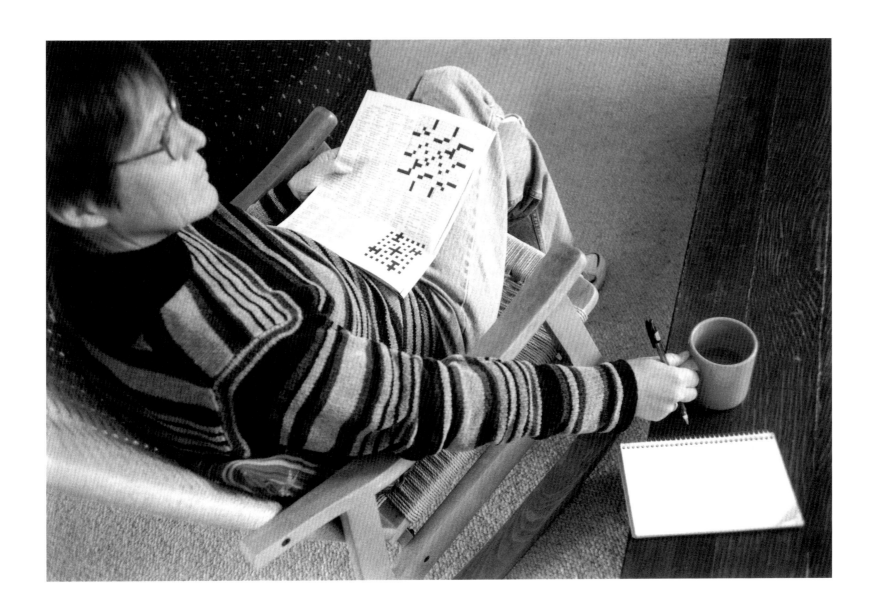

Niall O' Melia - Stinchfield

Treating myself

to a morning coffee at a cafe or

mall, either with a friend or

alone with my newspaper,

is a delicious luxury.

I feel totally free:

away from household chores,

ringing phones, carpools, deadlines.

A place where no one

can find me and

where I'm free to think, reflect

and just watch the world go by.

1995

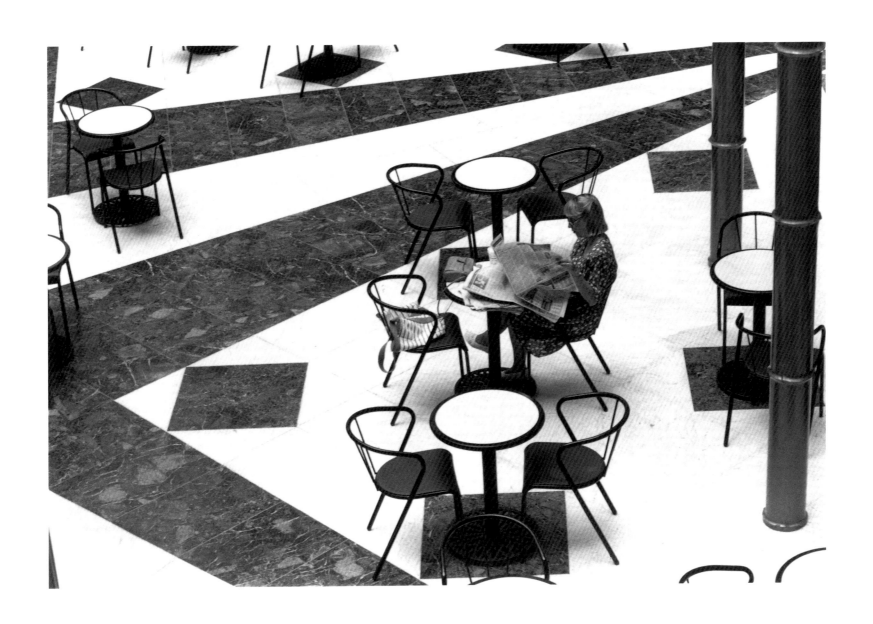

Helene Sze McCarthy
Mai Shih, Helene

Sometimes I close my eyes,

and I see my dream

right in front of me.

But sometimes

I don't know what I see because

my imagination is not really clear.

But one thing is very funny.

Every time I paint,

every stroke I put down,

I see and put it exactly where I want it.

I pick up the brush,

I swing it around,

I do all the strokes I wish.

1996

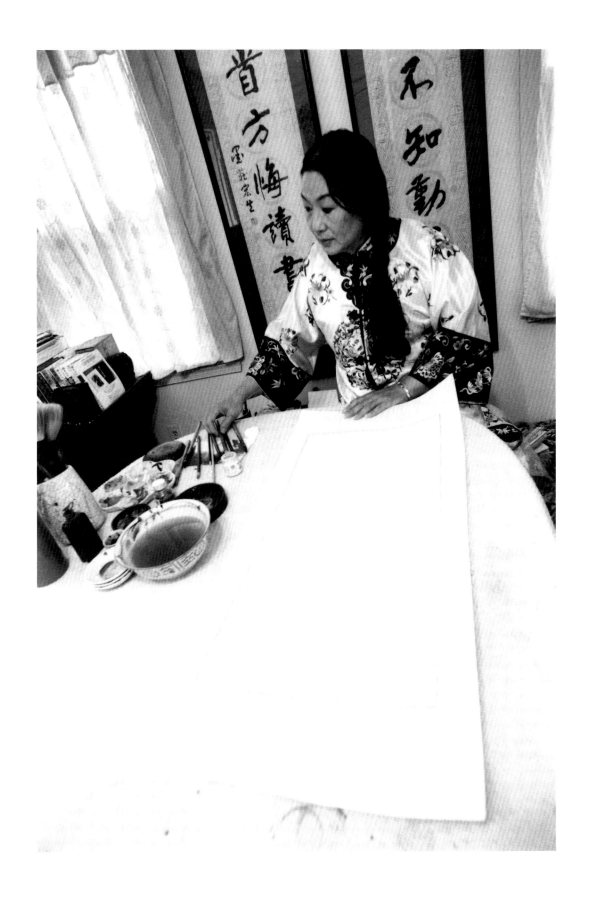

Elia Castillo

I like to be in my house.

It is peaceful.

I can do whatever I want.

I can take my shoes off,

relax, lie down on the couch,

not answer the telephone.

I don't like to talk on the phone.

I watch TV, old movies —

the special channel of old movies

is my favorite channel.

1996

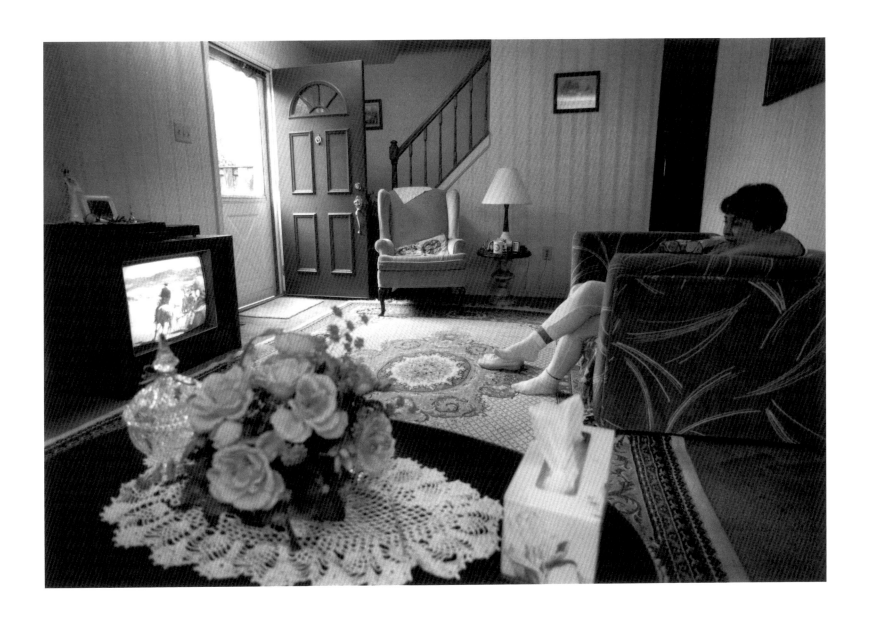

Jean Lawler Cohen

My work is related to words,

the give and take based on

language and visual tastes.

One block away, I retreat

to the impersonal environment

of a sports club.

Names, degrees, job descriptions,

opinions —

none of that matters here.

The payoffs —

a change of pace

in the midst of the workday,

a dispensation for the excesses of life

as a restaurant reviewer

and of course,

recreation

in its original sense,

a renewed sense of well being.

1998

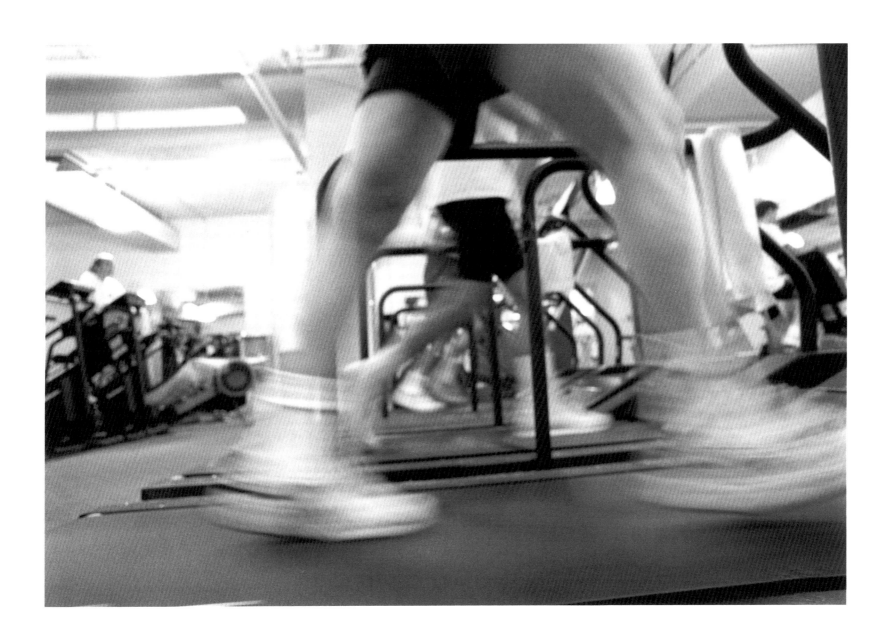

Marian Robertson
Chas Kuwu Tlaa

Writing poetry

is the first centering of my day.

Writing makes me realize

I'm still here with everybody.

I'm part of humanity.

I'm not by myself.

1997

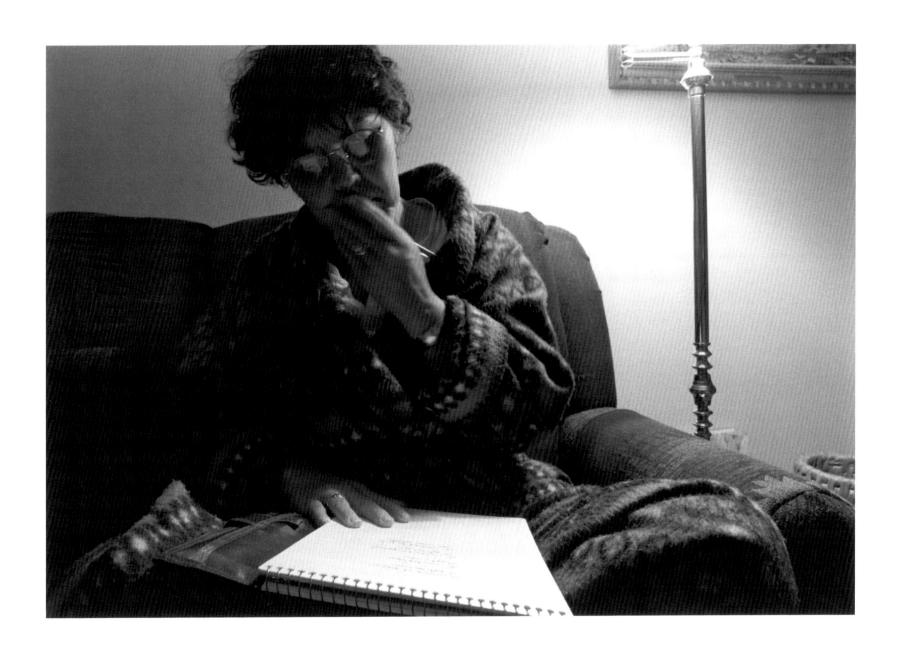

Bertha R. Ngenge

I like to do things with my hands.
Hammers and nails are a part
of my everyday life;
I am not afraid of them.
At 16 I followed my Dad around
doing odd jobs of building,
constructing, repairing, painting.
Going to Home Depot or
a lumber yard is like
Oh Whew!
Seeing an old house
that needs lots of work
gets my adrenaline flowing
because so much work is needed—
scraping paint, repairing a porch,
laying tile.
It is exciting to think about
what I could do.

Projects take effort,
and stretch what I know.
I am careful,
take measurements, re-measure,
and do things the long way around.
This kind of work
taps something in me
that isn't tapped
in my professional job.

1999

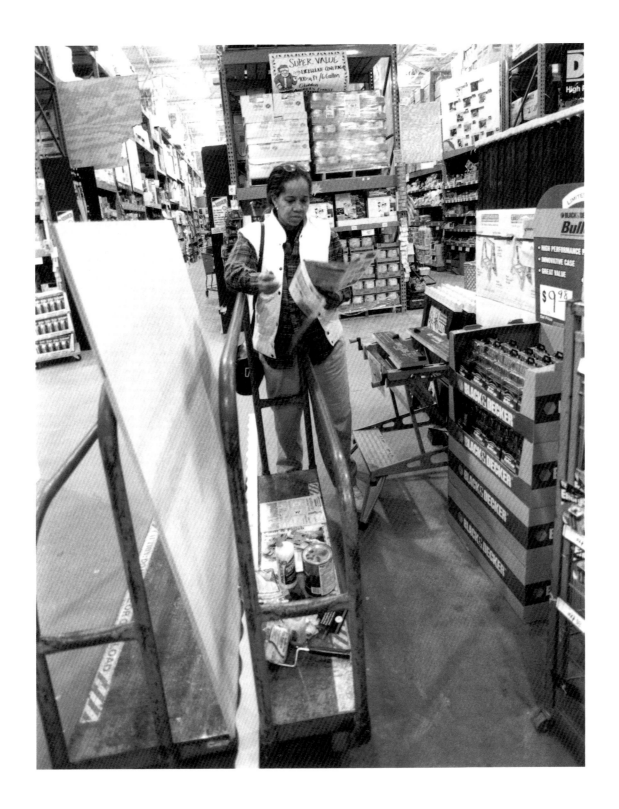

Helen Stuart

On a motorcycle I am anonymous.

I like that.

If you're female you get letched at alot.

With a helmet on

I don't get a second glance,

u n l e s s

they're looking at the bike.

1997

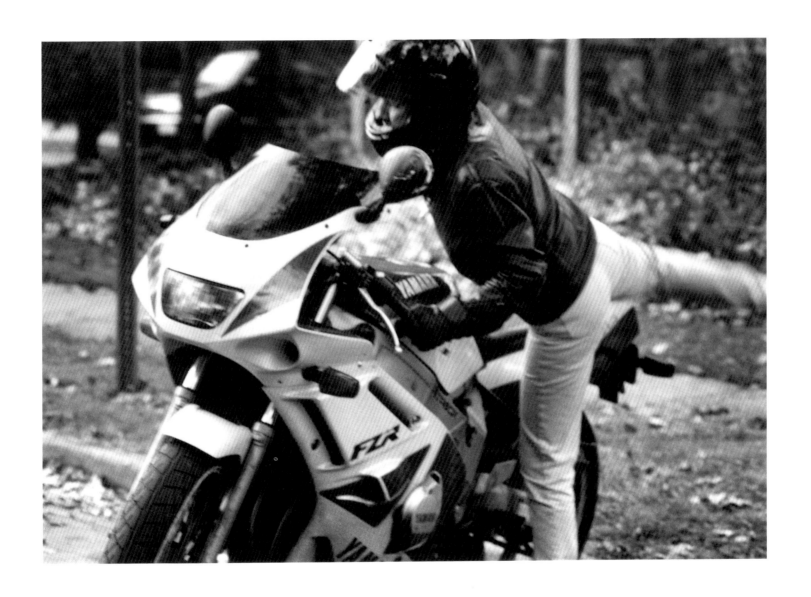

Maria Abarca

While gardening,

I am outside with the kids.

It's OK if they interrupt me.

We watch things grow.

This month the sweet figs

and purple grapes are ripe.

I change the plants around—

separating and dividing.

I'm relaxed and

get lost in my thoughts.

No one is telling me what to do.

1999

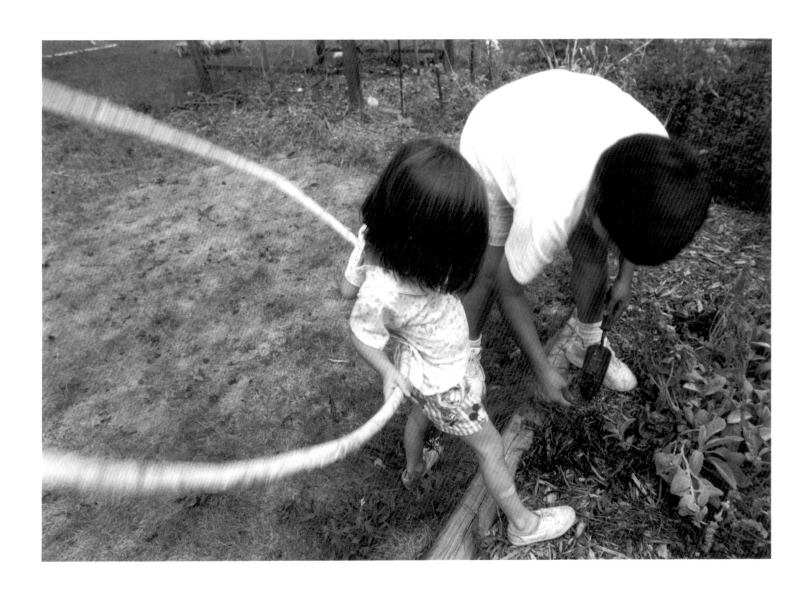

Nevzer Gulistan Stacey

Tango defies age.

While dancing the Tango,

a sadness escapes.

I am learning a life - skill

which I should have learned

a long time ago —

to love myself

enough to feed my soul.

1998

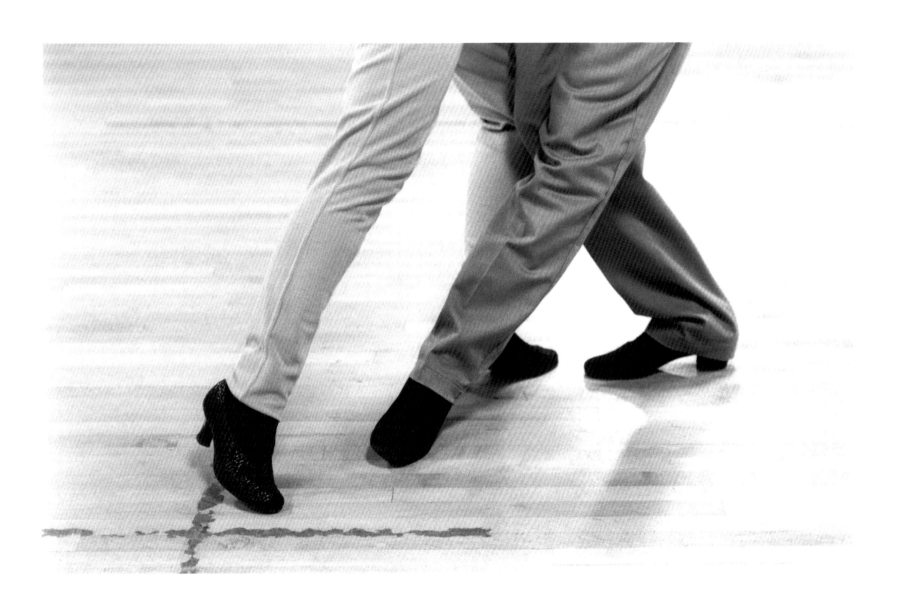

Patrice Yvette Ferris

Snuggling with my husband is

the most nurturing and

centering activity in my life.

Snuggling with Freddy makes me

feel safe, warm and loved.

I rest completely.

My soul is fed.

1997

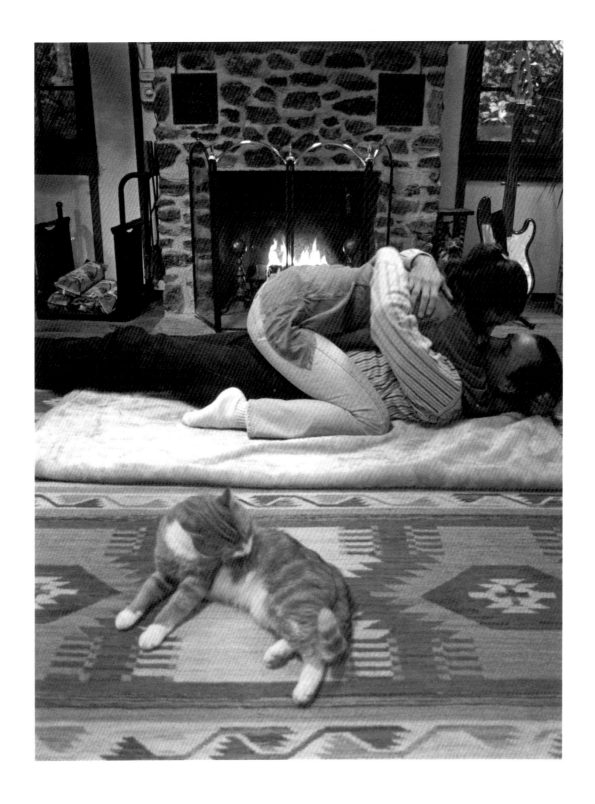

Miyuki Williams

The time had come for me

to make myself happy.

My living room had become

a storage place

for bicycles and boxes.

In unpacking the boxes

I started throwing away

what was not important,

and holding on to what was.

I painted the walls,

put in wooden floors,

bought a piano and sofa.

Instead of window coverings,

a magnolia is in the front yard.

It provides shade, privacy and fragrance.

At night I light candles.

What I was doing for my home

I was also doing for myself.

Now my home is a place

where I am happy.

1999

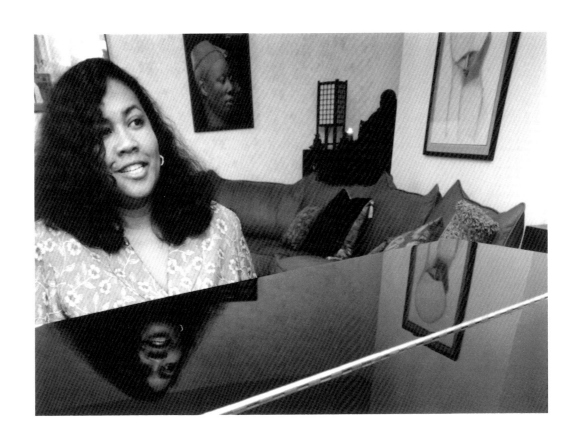

Constance Vieira Da Cunha

Before I fix dinner I listen to music—

jazz, ska, reggae, etc.

The drink relaxes me;

the music and cigarettes

give me energy.

1995

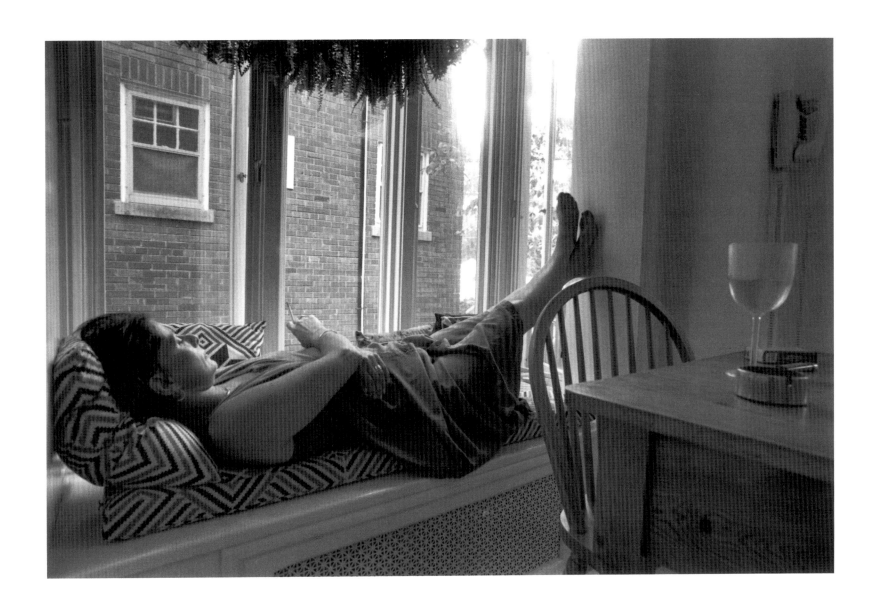

Pam Taylor

My bath is

a complete ending to my day.

A time just to be.

The water, the quiet, the oil, the bubbles,

the aloneness.

By the end of my routine,

I am very often sitting

with the towel draped over me

and no water, having let it go slowly away;

a bit like the end of a yoga class.

Yes, my day ends nicely,

quietly,

gently.

1999

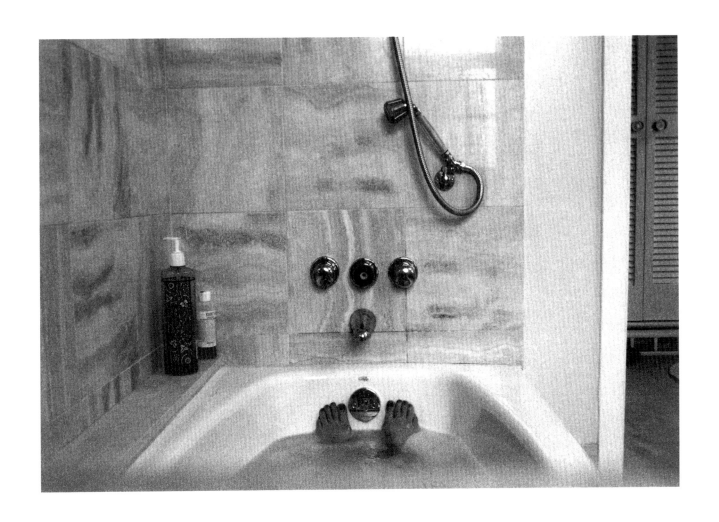

Michelle R. Knox

I like to primp

and take a lot of time

to fix myself up.

A real beautiful woman is inside and

I allow her to come out and play.

I love watching me come alive.

My soul peeks through.

1997

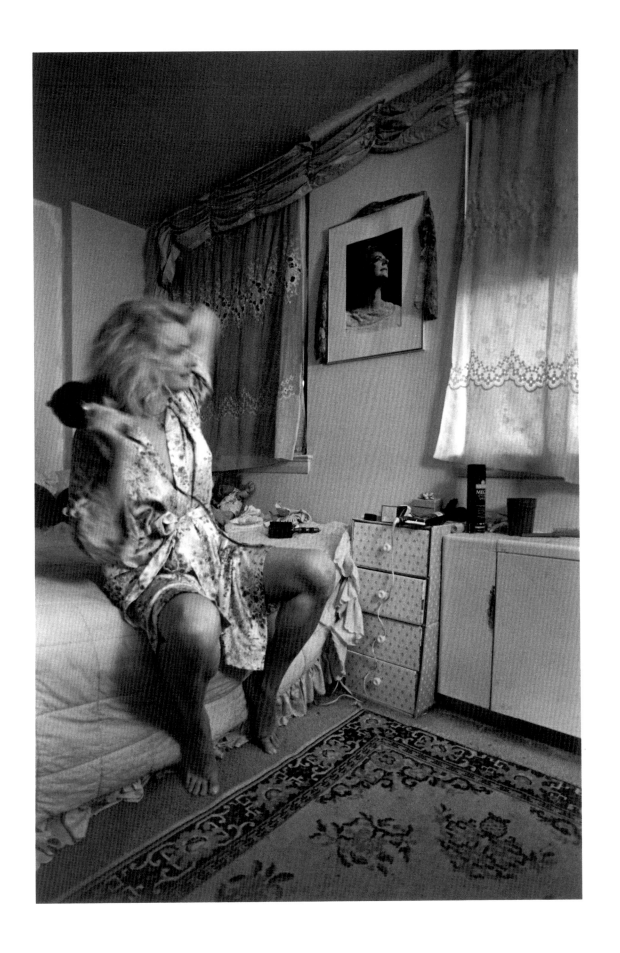

Tina Short

I dream and

make my dreams come true.

Right now I travel

the U.S., the world —

the moon.

I look at newspapers,

books, ads, deals.

Anything free I venture into

for my travels.

I am an opportunist.

My suitcases are packed

a month ahead of the trip.

1999

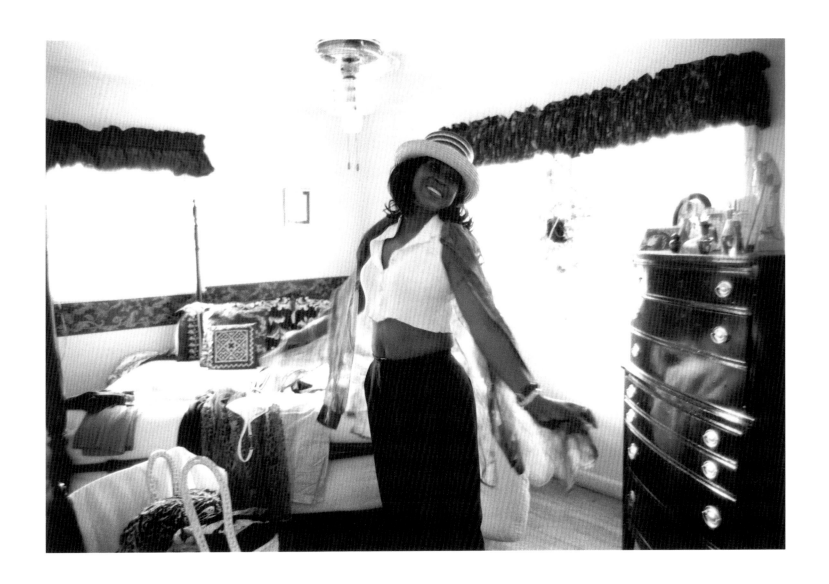

In Her Place

by Peggy Fleming
March 2000

Peeling and slicing onions for dinner, *All Things Considered* on the radio, dog sitting on my left foot — a nice time in my day. I wondered where other women's places of feeling good for a few minutes a day were. When I read Virginia Woolf's A Room of One's Own, Ruth Bender's Everyday Sacred and Anne Morrow Lindbergh's Gift from the Sea, I had been struck about the importance of having time for oneself. In Her Place records where, at the end of the 20th Century, 56 American women have found a place of nurture for themselves. In Her Place shares, in text and photographs, their personal sanctuaries.

From the beginning of this photo essay in 1995, it was to be of adult women and to reflect the multicultural environment of metropolitan Washington, D.C. My first thought was to contact well known women. I quickly realized that the interactions of my own life provided the richness of age and diversity I was seeking. The unanticipated benefit for me was that it provided a context for conversations and shared experiences with many women I already knew: neighbors, friends, teachers, relatives and business people. Since I already had

friendly exchanges with most of the women, it was easy to talk with them about being a part of In Her Place. For example, Ruth, a U.S. postal clerk, Kyung, owner of Lee's Laundry, Zahra, an exercise instructor at the local health club, and Elia, a beautician, are four of the 56 women in the book. Two of the women, Dorothy and Miyuki, I knew by listening to their programs on the radio while working in the darkroom.

Some women immediately knew their *place* and safeguard and treasure it. Some found the idea intriguing, but needed time to think about what they did just for themselves. Some thought their *place* was one thing, but when writing about it realized their *place* was somewhere else. All immediately understood what I was talking about, and all were curious about the choices of others.

The women in In Her Place mirror American society with its range of ages, multicultural diversity and professions. The range of ages is from 20's into 90's. The women are single, married, divorced, widowed. The women are Mom at home, Mom with a job outside the home, with small children, with teenagers, with adult children, with grandchildren, or with no children. Their diverse cultural backgrounds are sometimes evident in the wonderful names that accompany the photographs. Their occupations include computer programmer, housekeeper, student, manager of a human resources department, business owner (laundry, bookstore, restaurant), teacher, office manager, research psychologist, beautician,

photographer, exercise instructor, receptionist, magazine editor, U.S. postal clerk, singer, writer, education research analyst, poet, audio engineer, pharmacist, radio technician, radio commentator and National Park Service ranger.

Each woman's description about her choice of *place* is in her own words. The text was completed before the photography session. In most cases, I photographed for one to three hours. Alice Quatrochi put the simple, direct, personal prose into poetry by the way she arranged the lines. Any minor editing of the prose was done by me. The beauty of these texts was another unanticipated reward.

Each session in the darkroom was a fun, rich experience as I relived the relationship with each woman: our talking, settling on her *place*, receiving her text, and doing the photography session. Each was an adventure marked by trust and good will. Surprisingly, very few women wanted to see the results or to see the photo I selected. Most will see their photos for the first time when they look in this book. This project was my journey, and each woman in the book was part of it. Now that the prints are printed, the texts are poetry and the sequencing has been decided, I am thrilled with the result.

My thanks to each woman I photographed, to Ruby Takushi, Neva E. Marks, Alice Quatrochi, Frances Fleming and Pat Fleming. And thanks to those people who listened and offered critiques over the past five years, and suggested names of friends they thought would like to be included.

At each stage of life we have different ways of nourishing ourselves. A *place* today will be different tomorrow.

In Her Place is a book and an exhibition of 56 framed black and white photographs accompanied with the text by each woman. The Thanks Be To Grandmother Winifred Foundation awarded a grant for the first stages of this essay. The book and photographs will be in the permanent collection at Radcliffe College, Arthur and Elizabeth Schlesinger Library on the History of Women in America.

~

Before photography became my principal occupation, I worked on Capitol Hill and in the White House for John F. Kennedy, then as an elementary school teacher, an anthropologist and as a Ranger for the National Park Service, until I retired in 1994. I live in Washington, D.C. with my husband Pat. We have two grown children, Jennifer and Sam.

So where is my *place*? When the kids were young, it was a few minutes of solitude in the bathroom, with the door closed. After they were grown my nurturing went into the garden and botany. Today, my *place* is in my head, with an idea or picture, before it is actualized verbally or visually.

* appears on cover